Wild Birds

NORTH AMERICA'S MOST UNIQUE BIRDS

by Stan Tekiela

Adventure Publications
Cambridge, Minnesota

DEDICATION

To my mother, a dedicated environmental activist for all of her life.

ACKNOWLEDGMENTS

Many thanks to my good friends, colleagues and associates who help me in the pursuit of finding and photographing birds: Agnieszka Bacal, Rick Bowers, Marie DeGennaro, Lilla Gidlow, Ron Green, Rick Mammel, Jeff Miller, Terrance Petro, Frank Taylor, Amy Wasson and Jim Zipp.

All photos by Stan Tekiela except pg. 85 by Jim Zipp and pg. 137 by www.instagram.com/richardjsimonsen
Edited by Sandy Livoti
Cover and book design by Jonathan Norberg

10 9 8 7 6 5 4 3 2 1
Copyright 2018 by Stan Tekiela
Published by Adventure Publications
An imprint of AdventureKEEN
(800) 678-7006
www.adventurepublications.net
Printed in China
ISBN: 978-1-59193-778-4

TABLE OF CONTENTS

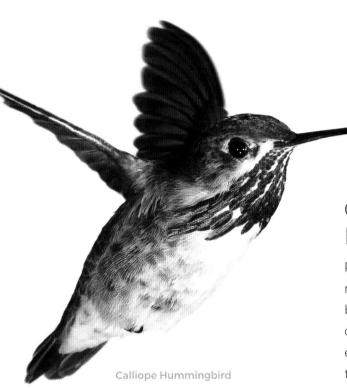

Calliope Hummingbird

OUR EXTRAORDINARY NORTH AMERICAN BIRDS

Plain and simple, birds are amazing! When you think about it, many birds are brightly colored and sing marvelous songs. Most build incredibly intricate nests. Some swim to deep depths, while others fly high above our tallest mountains. Birds occupy nearly every habitat on the face of the earth, from the hot tropics to the frozen poles. And if that is not enough, let's not forget the obvious—most birds have the ability to fly.

There are over 10,000 species of birds in the world. This is more than double the number of mammals on the planet. North America has its own highly diverse group of birds, with more than 900 species in the United States and Canada alone. From the tiny hummingbirds, which are often mistaken for large insects, to the giant eagles and condors, with their huge wings spanning 7–10 feet across, the variety is mind-boggling. North America is also home to the smallest of all owls, the Elf Owl, and the fastest of all animals, the Peregrine Falcon.

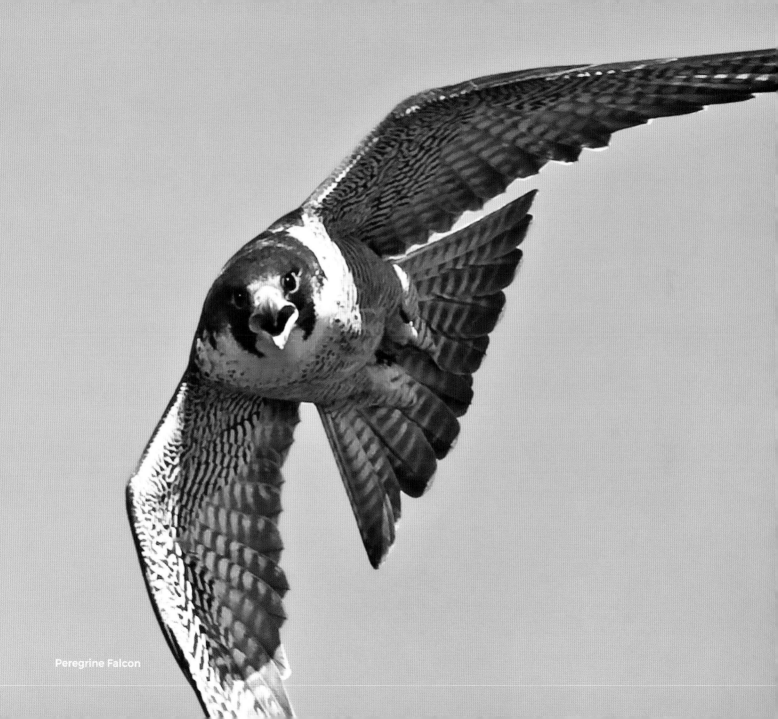

Peregrine Falcon

Just about every part of a bird's anatomy is specialized and unique. Nearly all species have super-strong flight muscles and an extraordinarily strong heart, both of which are needed to fly. Their lungs and air sacs are nothing like a mammal's and allow some birds to fly as high as 30,000 feet! At that altitude, a mammal would lose consciousness.

A bird's vision is greater than that of most mammals, and they see in a wider spectrum of light. This means they can see things that mammals, and certainly people, cannot. In addition, many bird species can hear way beyond the capability of people. Their navigational senses are unmatched in the mammalian world.

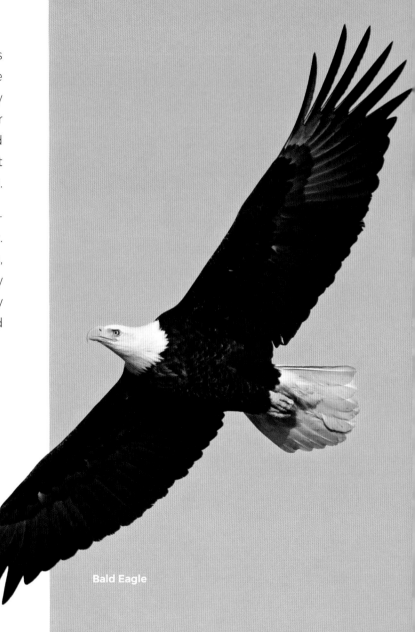

Bald Eagle

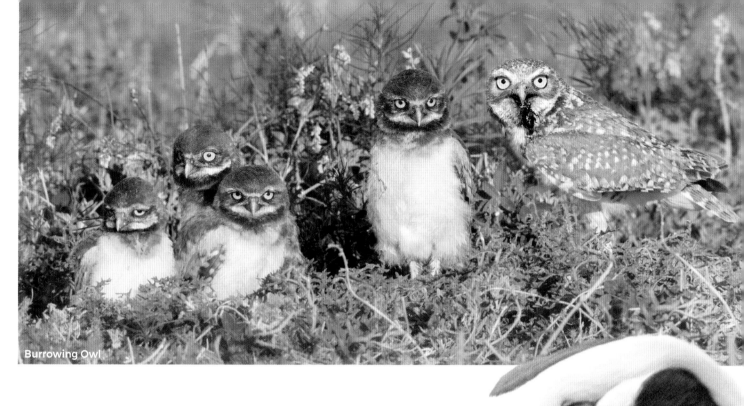
Burrowing Owl

The bills of birds are unique to the avian world. Birds use them for everything from building highly structured nests to procuring food. Some fight with their bills. Others use them to kill prey for meals. Birds also utilize these same bills to gently feed their babies.

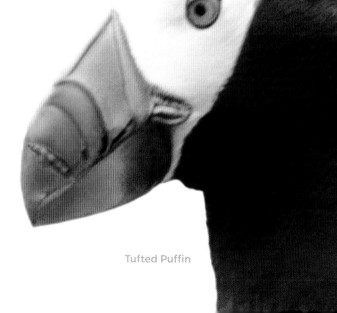
Tufted Puffin

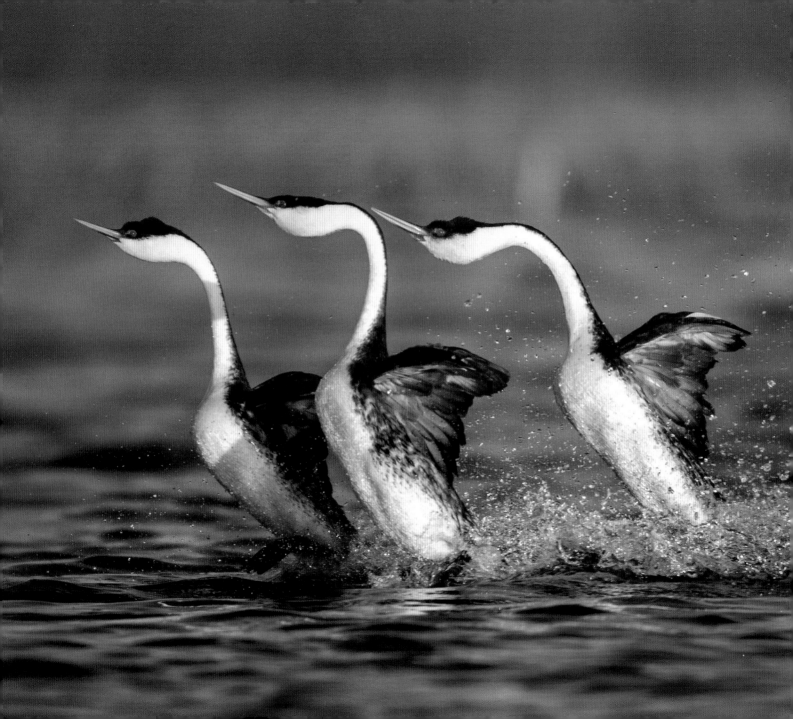

Western Grebe

Birds communicate both visually and with sound. Bright feathers and bold patterns say much about a bird's health and social status, and probably even more than we realize. Birds sing songs to express emotions, attract a mate, and communicate the ownership of a territory. Think of this as a complex song and dance show.

Wild Birds celebrates some of our most outstanding wild birds in their richness and diversity. I have carefully selected 28 North American species to showcase in this book. They include unique birds that are the most unusual or entertaining, and those with fascinating behaviors. Some of these species have also set records as the fastest, slowest, largest or smallest bird in North America.

SPOON-AT-THE-READY STALKER

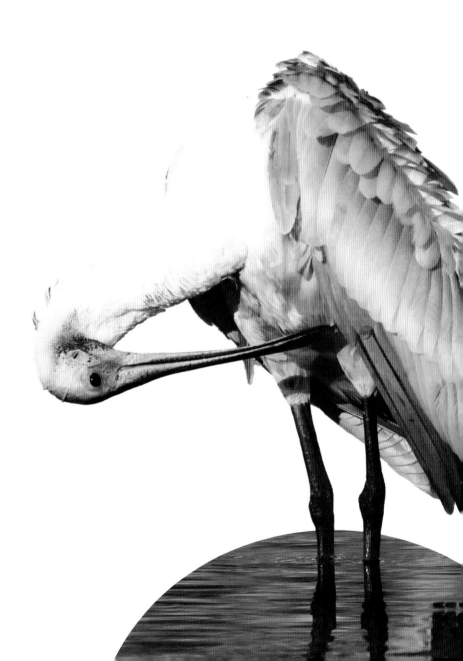

▶ **roseate spoonbill**

You almost need to blink hard and rub your eyes when you see one of these weird and wonderful, nearly 3-foot-tall birds for the first time. They just don't look real! Besides, it's not every day that you see a pink bird.

There are six spoonbill species in the world, and they all have extraordinary long bills with flattened, spoon-shaped tips. The Roseate Spoonbill is the only pink-colored spoonbill, as well as the only spoonbill species in North America. Males and females look the same, but the males are slightly larger and often have a longer bill with a larger spoon-shaped tip. They look elegant from afar, but their unusual bill gives them a wacky, if not bizarre, appearance at close range.

The color differences you see among these birds, including their deep pink legs and feet, are due to age and diet. Like the flamingo, the pink color of the spoonbill is the result of a carotenoid pigment derived from their diet. Colors range from a delicate pink to a much bolder magenta, depending on the bird's age and health. Young spoonbills are white and gradually turn pink as they mature into adulthood at 3 years of age.

When traveling from one area to another, spoonbills fly in long, diagonal formations or straight lines, with one bird lined up right behind another. In flight, they stretch out their legs and necks and flap with wingspans of over 4 feet.

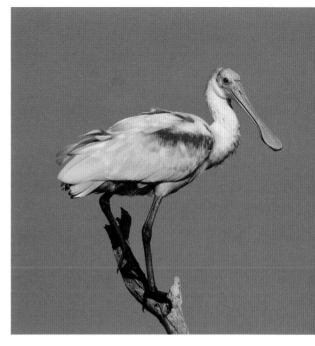

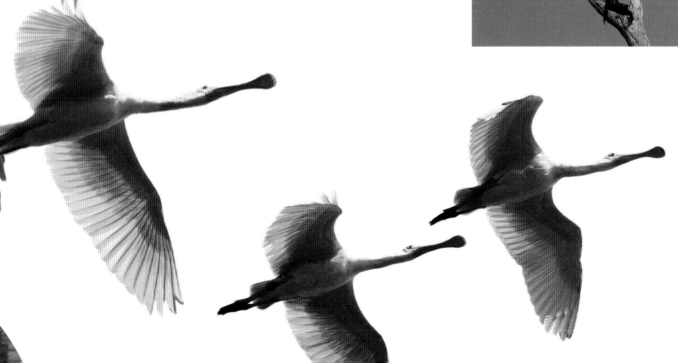

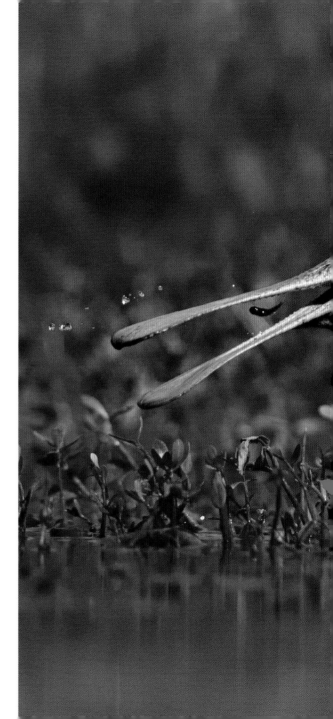

These tall wading birds are found across the entire Gulf Coast from Texas to Florida. Gregarious, they nest in small colonies, building stick nests in trees. The male and female build the nest, and pairs also share the responsibilities of raising the babies. Both parents rotate incubation duties and take turns feeding their young after the eggs hatch.

Spoonbills are usually seen in flocks of up to 30 birds or more, stalking quiet backwaters, using their highly specialized bill to catch small fish, shrimp and other crustaceans, snails, aquatic insects and small amphibians. They walk steadily through shallow water, sweeping their spoon-tipped bill from side to side. Touch receptors inside the bill enable them to feel small prey. When they find something to eat, they clamp onto it and toss their heads back, which throws the prey into their mouths.

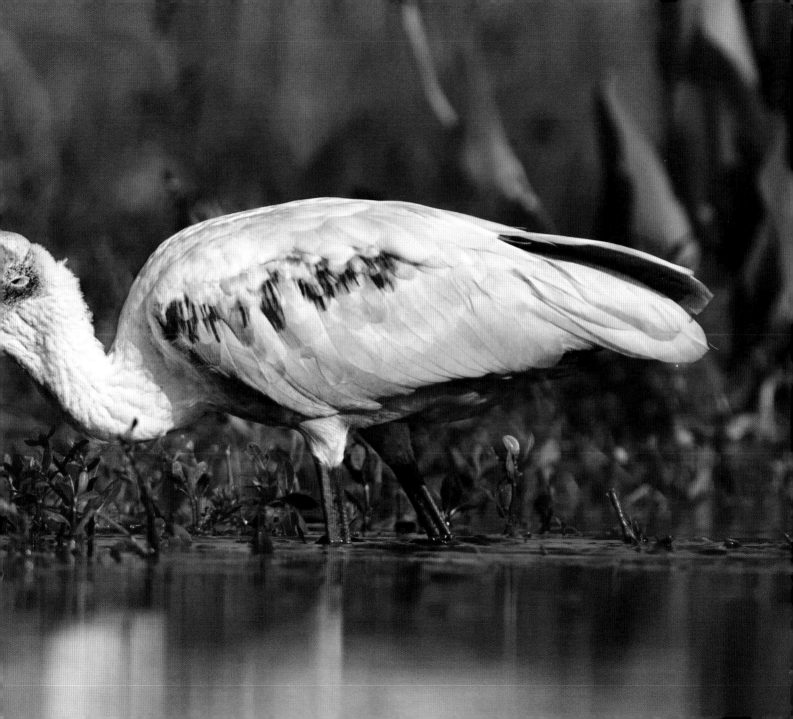

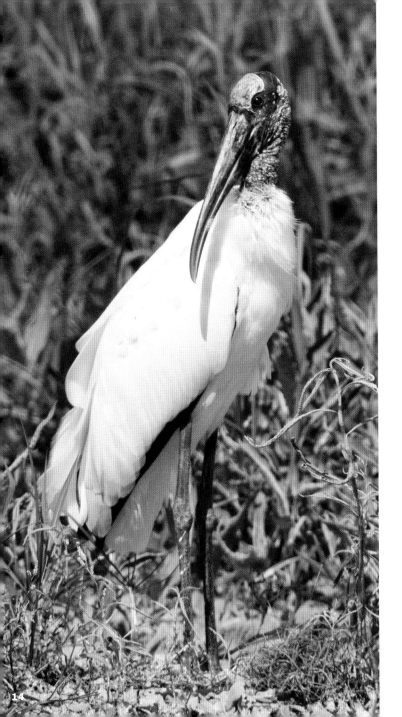

ANCIENT VISAGE FOR 10,000 YEARS

▶ **wood stork**

In contrast to the fresh pink of the spoonbill, the Wood Stork appears oddly prehistoric. A close relative of the spoonbill and the ibis, this is the only stork native to North America. Fossils of a Wood Stork (or a "sister" stork—one that is very similar) were found in Brazil and date back about 10,000 years. Tropical in origin, these birds haven't expanded their range beyond their original roots.

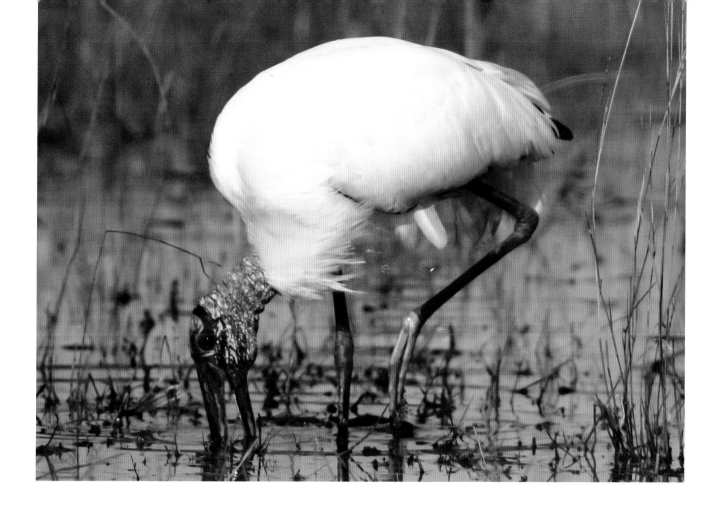

Wood Storks are peculiar-looking wading birds with bald heads and necks. They are large-bodied, with dark legs and pink feet. On the hunt in the water, their long legs help them to wade easily as they maneuver their feet to stir up food from the bottom.

While stalking for prey, storks keep the tips of their open bills in the water. When they feel something, they snap their bills shut, capturing the meal. Fish are the main diet but not their only food item. They also enjoy frogs, toads, snakes and large aquatic insects.

Wood Storks nest in small colonies, usually in cypress trees or in mangrove islands over water. Carrying sticks and twigs to the nesting site in their 10-inch-long bills, they construct their nests. They reuse these nests for many seasons, constantly improving them.

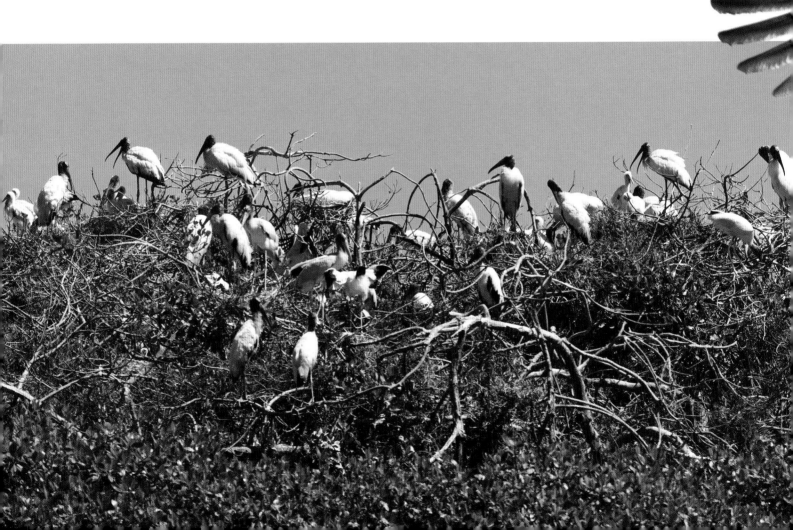

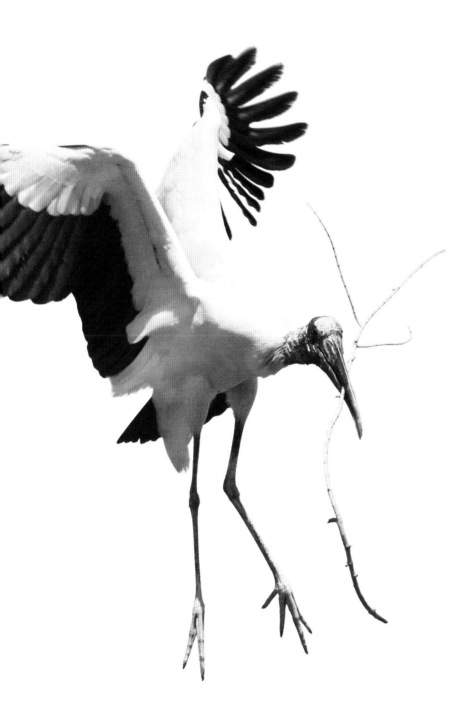

Storks nest only once per year, laying 3–5 eggs in a clutch. Both parents take turns incubating for nearly a month before the chicks hatch. Parents bring small fish to the babies in the nest for nearly two months.

Because the babies are in the nest for so long, the parents need a constant food source. It makes sense that they nest in the dry season, when smaller ponds dry up and expose more fish. If sources of fish are meager during the year, the parents will skip the next breeding season.

Juvenile storks are white with yellow bills. As they age, their heads and necks become bare, exposing dark skin, and their bills turn dirty gray. They don't become sexually mature until at least 4 years of age.

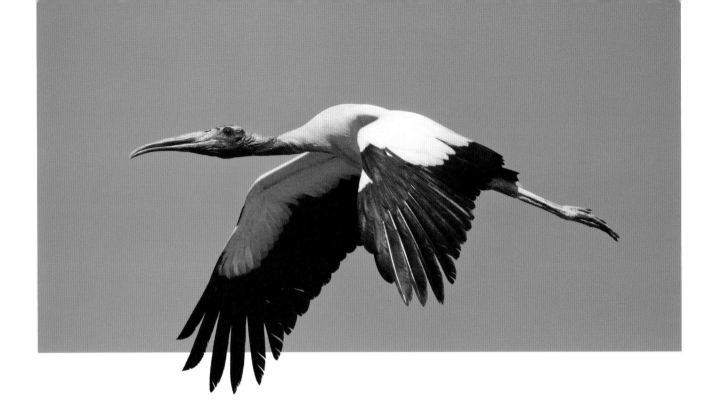

When storks move from one feeding area to a better one, it's not uncommon for them to fly at high elevations. They have broad wings that span 5 feet across, making it easy to soar on natural updrafts, called thermals. They ride the thermals before landing at the next shallow-water feeding area where more fish are concentrated.

Stork populations have never been very high in North America, and small populations occur in southern states, such as Florida, Georgia and South Carolina. An endangered species for many decades, storks were upgraded to a threatened species in June 2014 due to recovery efforts and laws that protect the birds. Today, the Wood Stork is on its way to becoming an avian success story.

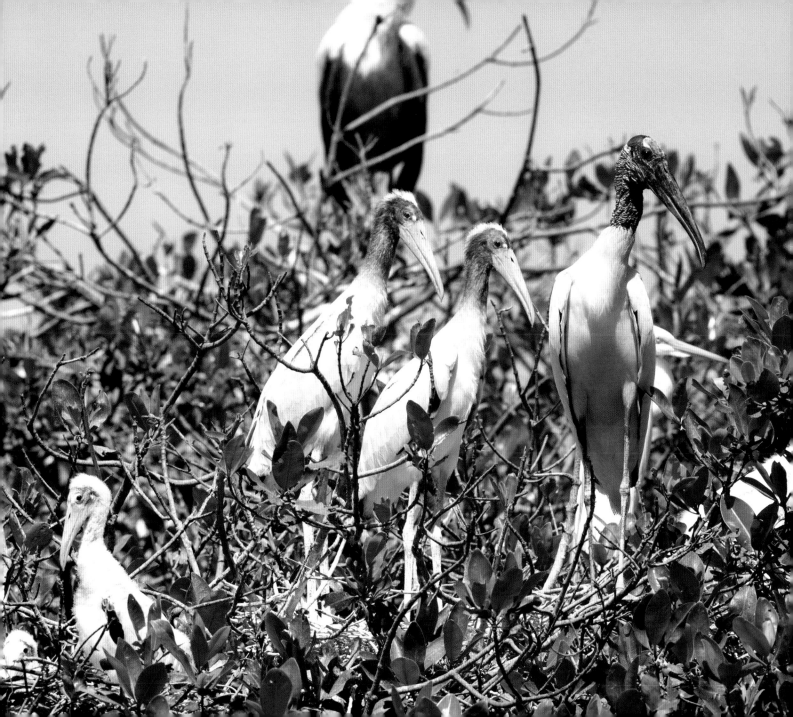

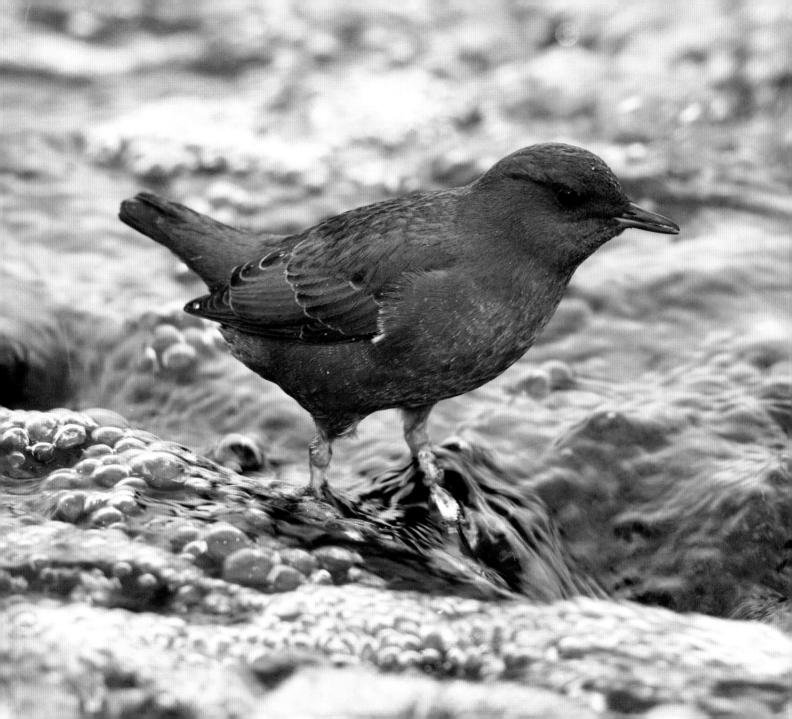

DIVER, DIPPER, BOBBER, BLINKER

▶ **american dipper**

At first look, the American Dipper might not seem like a very interesting bird. It's a stocky, dull gray bird with a short black bill. While it may appear unimpressive, just watch it a few minutes longer and you will appreciate this astonishing little bird.

The dipper is North America's only aquatic songbird. Acting more like a waterbird, it lives next to fast-running mountain streams in western states and northward through British Columbia into Alaska. It sings a melodious song, but it's best known for diving and dipping into swift, cold, clear-water streams in search of aquatic insects, including the larvae of mayflies, caddisflies, dragonflies and damselflies. It also eats worms, snails, small fish and fish eggs.

Amazingly, this songbird plunges headfirst into a rapid, frigid stream and completely submerges. Using its wings as if flying underwater, it pushes along with its feet, fighting the current to snatch a meal off the bottom. Returning to the water's edge to eat, it often will bang the prey repeatedly against a rock to kill it before swallowing the food. Then it goes back and dives into the water to search for the next morsel.

Flying low across the water's surface, the dipper moves from one hunting location to another. Standing alongside a stream, this bird has a distinctive habit of bobbing or pumping its body up and down. Many mistakenly liken the action to deep knee bends, but in reality the dipper is flexing its ankle joint to achieve this movement.

The American Dipper has a delightfully sweet song, but it can barely be heard over the roar of rushing water. There are white feathers on its eyelids, which make it look like the bird is flashing white with each blink. Combine the blinking with the bobbing up and down and the wonderful song, and it's a sight to be seen.

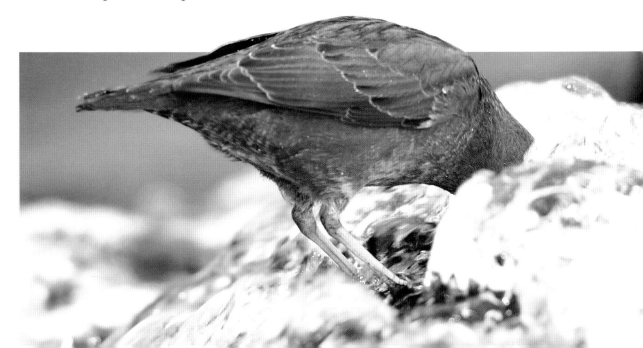

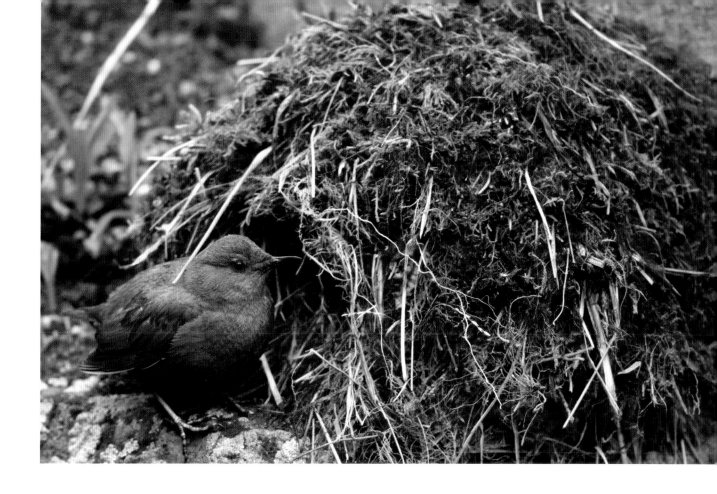

As if that weren't enough, the dipper also constructs a fantastic domed nest that is larger than a soccer ball, with an entrance low on one side. Usually made with mosses, other green plants and rootlets, the location is often under a waterfall or next to an especially splashy part of the stream, which keeps the nesting material damp.

The American Dipper is one of five dipper species worldwide, and it's the only one in the United States. It is also known as the Water Ouzel, which means "water blackbird." The common name "Dipper" was given because the bird is constantly bobbing its body up and down while it stands or walks. Some say the name refers to its unique head-dipping action to find food.

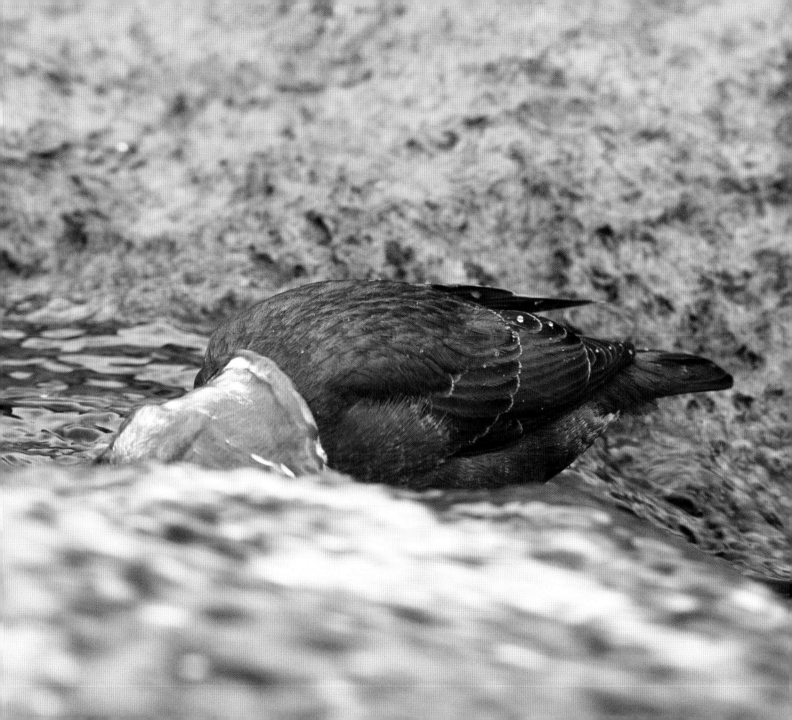

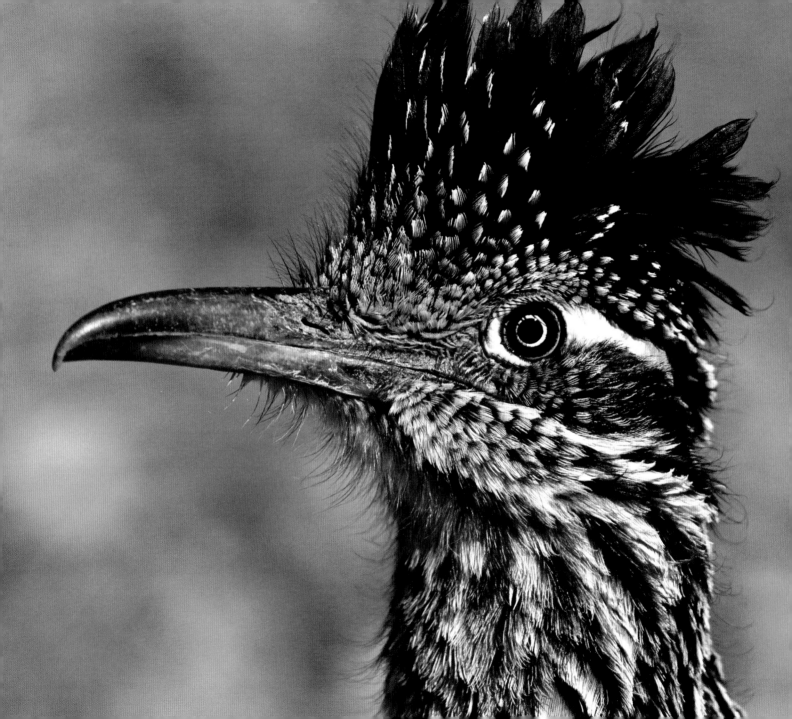

WATCH OUT— SPRINTER APPROACHING!

▶ greater roadrunner

To some people, the roadrunner is best known as a fleet-footed cartoon character that is always outsmarting a wily coyote. The Greater Roadrunner is an almost mythical bird to anyone who hasn't traveled to the American Southwest or lived there. It's often a bird that you've heard about but never seen. And everyone seems to have all sorts of questions about the roadrunner. Does it really run that fast? Can it really outwit a coyote?

The roadrunner is an odd-looking bird with a long, narrow body, an extremely long tail, and long legs. A member of the cuckoo family (Cuculidae), it is, in fact, the largest of the cuckoos in North America. Sometimes it's called the Ground-cuckoo because it spends most of its time on the ground and prefers to run rather than fly. Its scientific name, *Geococcyx californianus*, translates to "California Earth-cuckoo."

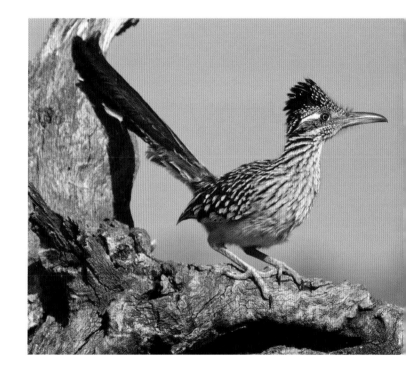

Males and females look alike, but the males are slightly larger. These birds are capable of running upwards of 20 mph, which, believe it or not, is still not fast enough to outrun a coyote. It has been reported that the fastest roadrunner reached 26 mph. This is the fastest running speed of any bird that is capable of flight. Flightless birds can run much faster.

Roadrunners have large, uniquely shaped feet. While most birds have three toes that point forward and one pointing back, roadrunners have two toes forward and two back. They have what is known as zygodactyl feet.

Roadrunners use their specialized feet to speed-run and catch small mammals, such as mice and shrews. They also hunt snakes, scorpions, spiders and other large insects. They have even been known to take on venomous snakes, such as rattlesnakes. They kill their prey by repeatedly whacking it against a rock before swallowing the item whole.

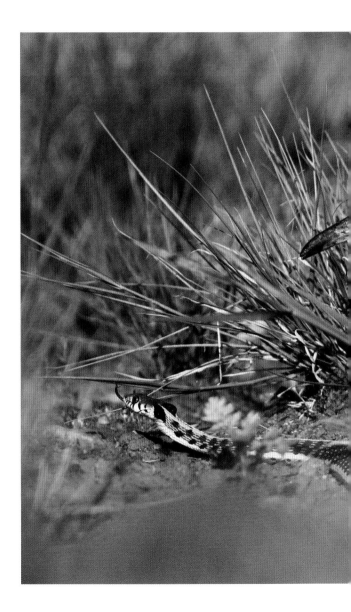

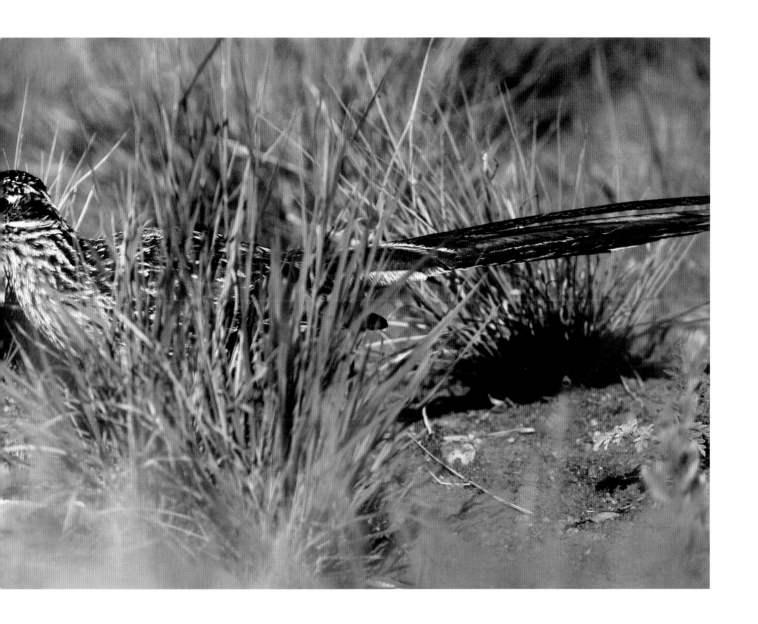

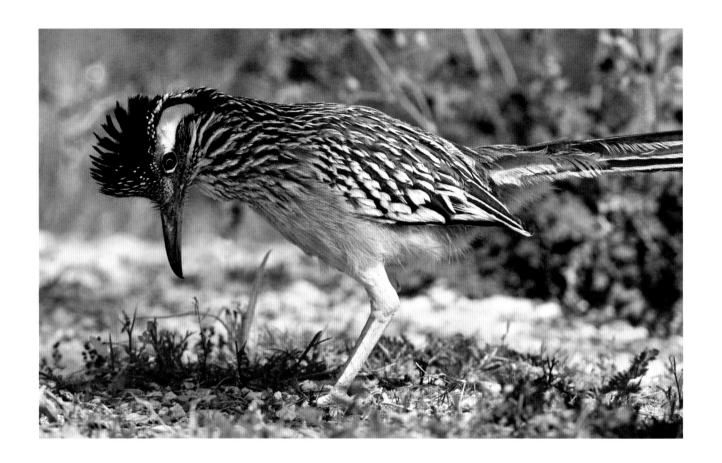

It is thought that roadrunner pairs stay together for long periods, perhaps many years, defending their territory together year-round. In late winter and early spring, males display for the females by wagging their tails back and forth and lowering their wings. A male will expose a pink and light blue patch behind his eyes and make a loud cooing sound while raising the crest on top of his head.

I remember the first time I saw a male displaying this elaborate dance to a female. I watched in fascination as he bowed his head nearly to the ground, exposing his brightly colored skin patch, while calling a slurred "coo-coo-coo." The sound of that mating call was unforgettable, and I can recall it clearly to this day.

Many people have fun feeding roadrunners that visit their yards. Friends of mine once told me about a determined roadrunner that would come to their home several times a day and bump against their sliding glass door, begging to be fed. They would throw out cooked meatballs, which the bird immediately gobbled down.

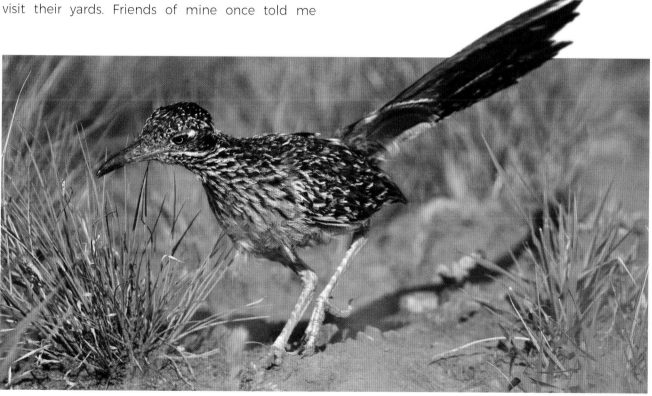

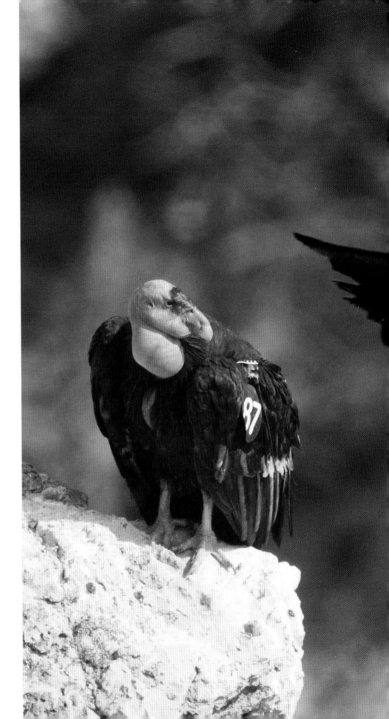

RARE, BUT TOO HUGE TO MISS

▶ **california condor**

The California Condor is perhaps one of the most endangered birds in North America. Considered a New World vulture, it is the largest land bird in the continent. Soaring on huge wings that stretch out 9–10 feet, the condor looks more like a small airplane than a bird.

Nearly driven into extinction, the last remaining 27 condors were captured in 1987, removed from the wild, and put into breeding programs. The indivduals that were released back into the wild were tagged.

Unfortunately, condors 6–10 years and older are the only ones that will breed, and since they produce only one egg every other year, this makes for a very slow recovery program. Even now, condors remain one of the rarest birds in North America.

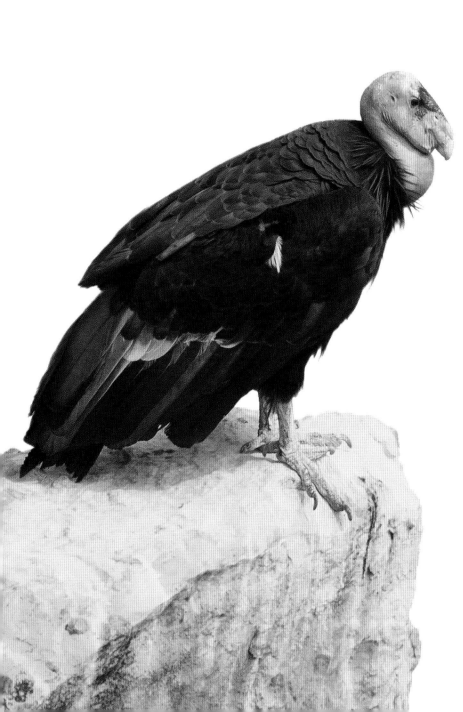

Today, the California Condor soars over only a tiny fraction of its original habitat. Starting in 1991, it was successfully reintroduced into northern Arizona and southern Utah, including into Grand Canyon and Zion National Parks. A second population was reintroduced along the coast of southern and central California.

Because condors are ancient birds, it is believed that they once lived off the carcasses of now-extinct large animals (megafauna), which roamed North America eons ago. It's been proposed that the absence of these food sources may be the reason for the major decline of the condor population. Despite this, the California Condor can live 60–80 years or more, perhaps making it the longest living bird in North America.

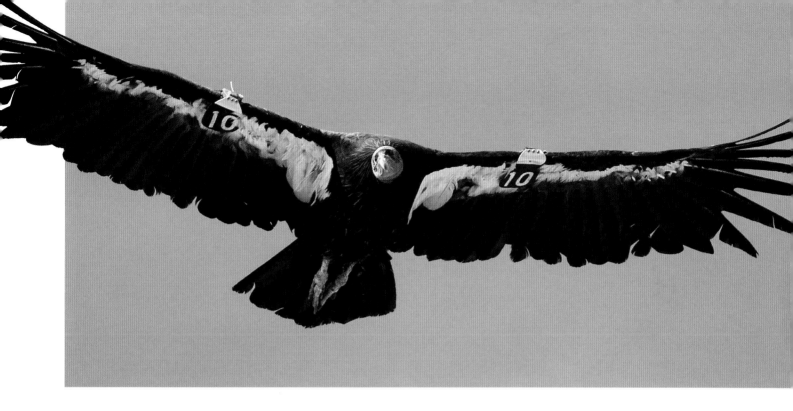

Adults are jet-black except for a white patch under each wing that is only seen in flight. There is a unique frill of feathers surrounding the base of the neck. The upper neck and head are naked, and the skin flushes with colors in response to emotional states. Skin color ranges from yellow to orange and sometimes red.

In flight, condors are graceful and fluid. Because their wings are so large, they glide and soar more than they flap. They lack the typical sternum that supports large muscles, which give power to flapping. They often go for many miles without flapping and are capable of soaring as high as 15,000 feet above the ground.

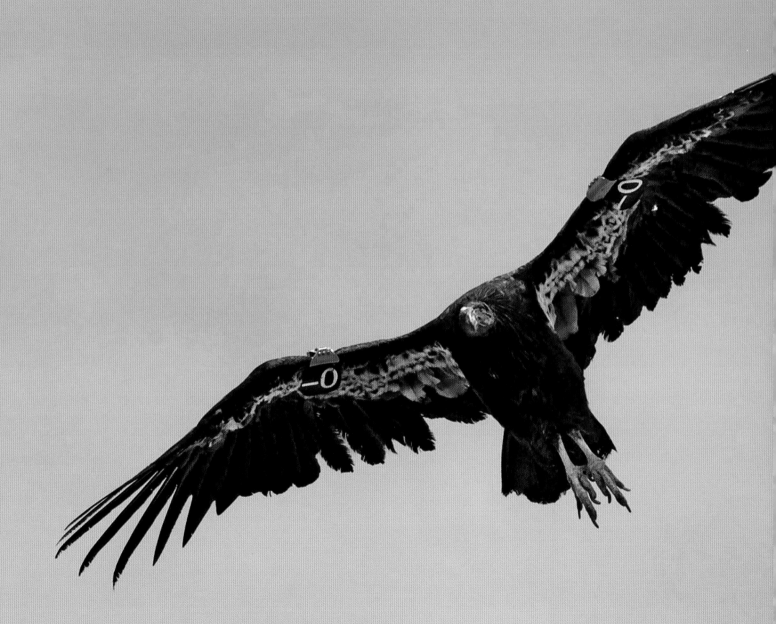

California Condor and Common Raven

California Condors have a huge home range and can cover more than 250 miles a day in search of dead animals (carrion). One of my favorite places to see condors in their territory is at the South Rim of the Grand Canyon. During the warmer months they soar and play on the updrafts of wind at the canyon rim. Other birds, such as Common Ravens, which are large birds themselves, also ride the winds throughout the canyon.

Once when I was filming a condor and a raven in flight together, vacationers behind me exclaimed about the "baby condor" flying with the parent. It's easy to make this mistake if you don't know that juvenile condors don't look like ravens. Instead, they have huge wingspans and look like adult condors but with gray skin on their heads.

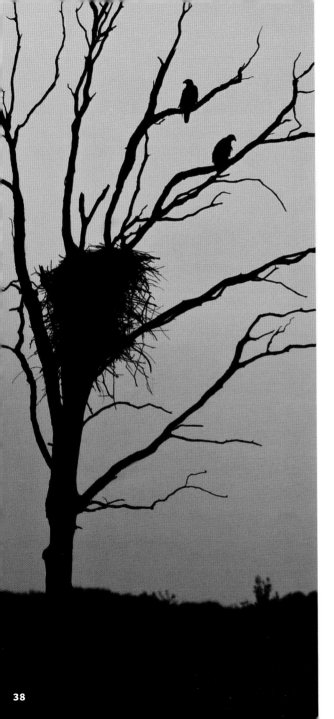

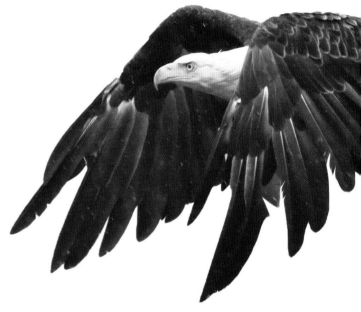

MASTER CARPENTER, BUILDING WITH STICKS

▶ **bald eagle**

The bold and beautiful Bald Eagle, the U.S. national bird, appears on the Great Seal of the United States. Bald Eagles are not actually bald, as their name implies. "Bald" derives from an older use of the word *balde*, which meant "white-headed."

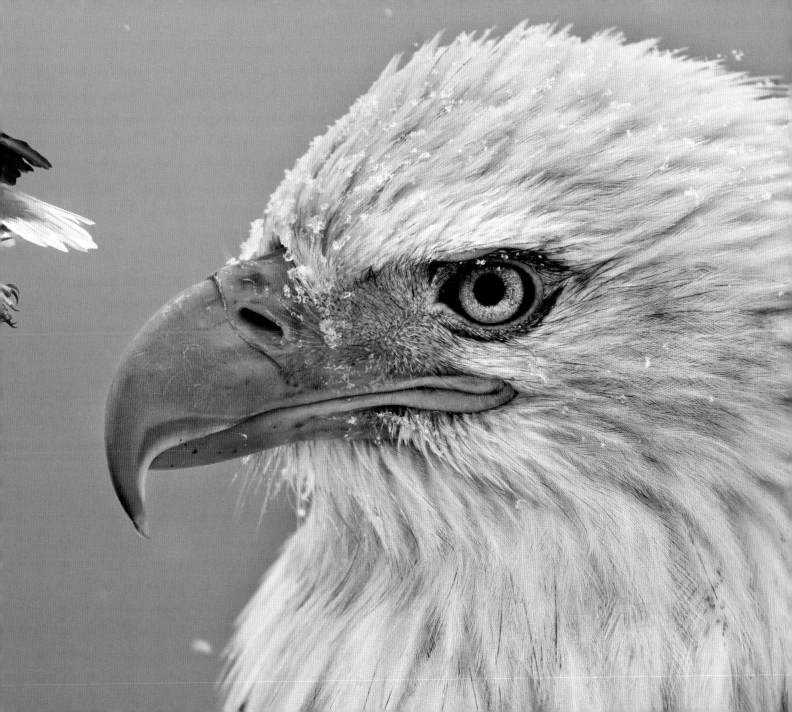

Males and females look exactly the same, but females tend to be upwards of 20 percent larger. It is difficult to tell them apart unless they're perching next to each other.

While adults appear to be black and white, they are actually brown and white. Juveniles are splotchy brown and white for the first 5–7 years of life. Only when they reach full adulthood do they obtain the bold dark body and striking white head and tail.

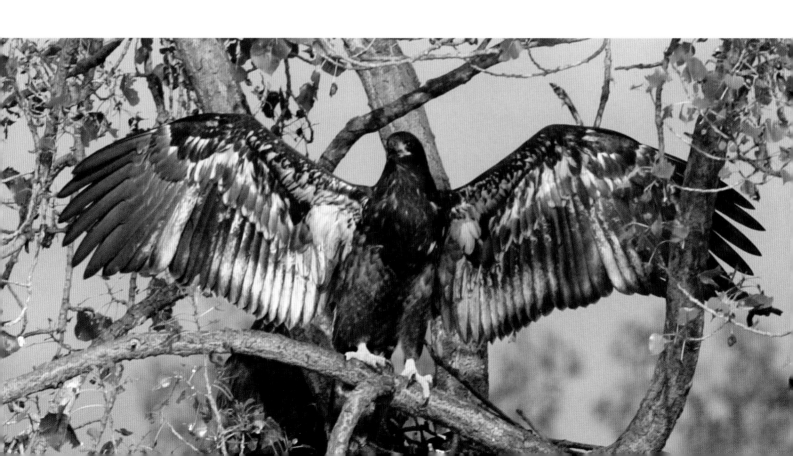

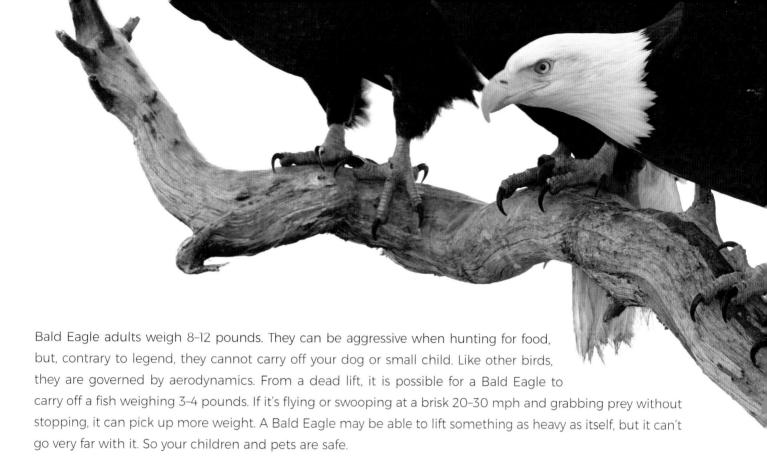

Bald Eagle adults weigh 8–12 pounds. They can be aggressive when hunting for food, but, contrary to legend, they cannot carry off your dog or small child. Like other birds, they are governed by aerodynamics. From a dead lift, it is possible for a Bald Eagle to carry off a fish weighing 3–4 pounds. If it's flying or swooping at a brisk 20–30 mph and grabbing prey without stopping, it can pick up more weight. A Bald Eagle may be able to lift something as heavy as itself, but it can't go very far with it. So your children and pets are safe.

I often hear illogical tales about a Bald Eagle at a lake, attempting to grab a fish so large that the bird is unable to lift it. These stories maintain that the eagle could not release the fish due to a locking mechanism in its feet, and as a result, the eagle drowned—all of this is not true.

First, if a Bald Eagle actually had a locking mechanism in its feet, every time it landed on a branch it would have trouble letting go. Second, a typical Bald Eagle is covered with over 7,000 feathers. Each of these feathers has a hollow shaft that traps air, creating the effect of wearing a full-body life jacket, making it nearly impossible for the bird to drown.

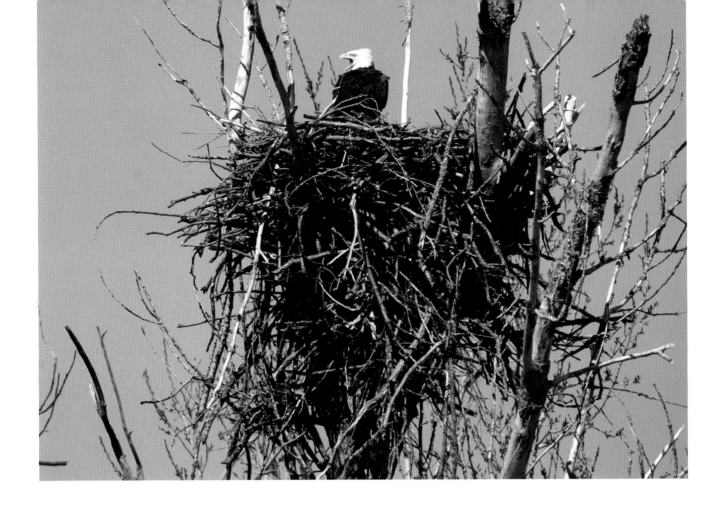

Bald Eagles are master builders, constructing the largest nests of any bird in North America. Comprised of small to large sticks, nests are constantly being remodeled and expanded, growing in size over time. Nests need to be large enough to house upwards of four young eaglets. Many record-setting nests were found to be up to 20 feet deep and 10 feet wide, and a nest in Florida was estimated in 1963 to weigh nearly 3 tons! Many of these nests were used for decades, up to around 20–30 years.

Hunting and the overuse of the pesticide DDT caused the Bald Eagle to become nearly extinct, with populations hitting an all-time low in the 1960–70s. Populations have since rebounded under the protection of several environmental laws. In July 1995, the Bald Eagle was placed on the endangered species list, but it recovered well enough to be removed in June 2007.

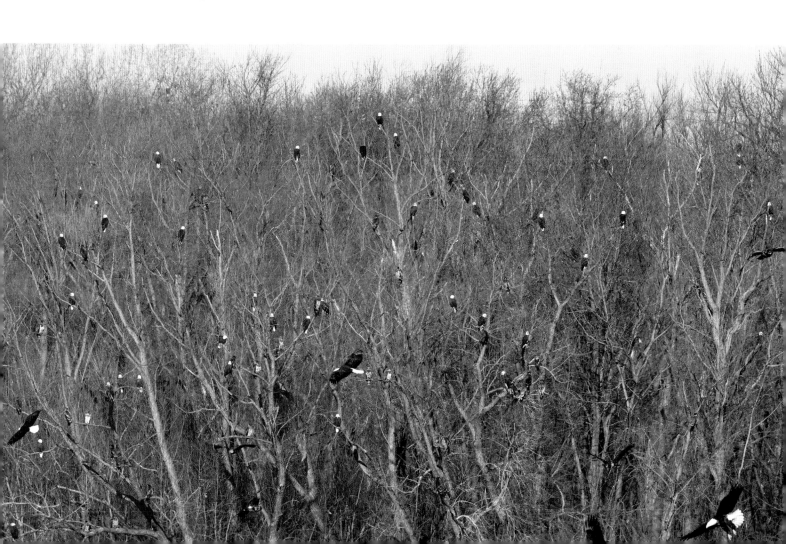

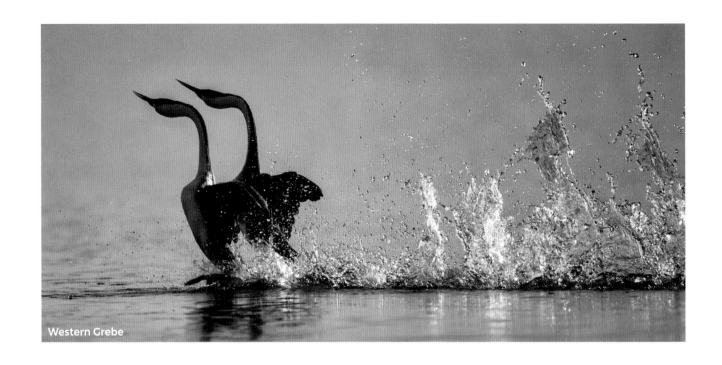
Western Grebe

RUSHING AND WEED DANCING ON THE WATER

▶ **grebes**

When I was young, I watched *The Wonderful World of Disney* on Sunday evenings. Every now and then the show would air a short video clip, set to classical music, of Western Grebes running across the surface of the water. I was mesmerized by their behavior, and now every time I photograph grebes, I think of those marvelous childhood memories.

The Western Grebe and its nearly look-alike cousin, the Clark's Grebe, are the only waterbirds to perform such an amazing and elaborate display. Shortly after returning to their natal lakes to breed, they begin to display and form pairs. One of these displays is called rushing.

When grebes rush, two or more individuals leap out of the water and run side by side, cocking their necks and heads while drooping their wings. A rush can take place in just a few yards, or cover 30–40 yards or more. All the while the feet are splashing water in all directions very loudly. At the end of the rush, the participants dive headfirst into the water and slip beneath the surface.

Rushing can occur between a male and a female, two females, two males, two males and one female, or any combination of these. The variety of partners indicates that grebes rush not only to attract and court a mate, but also to compete with each other for a mate.

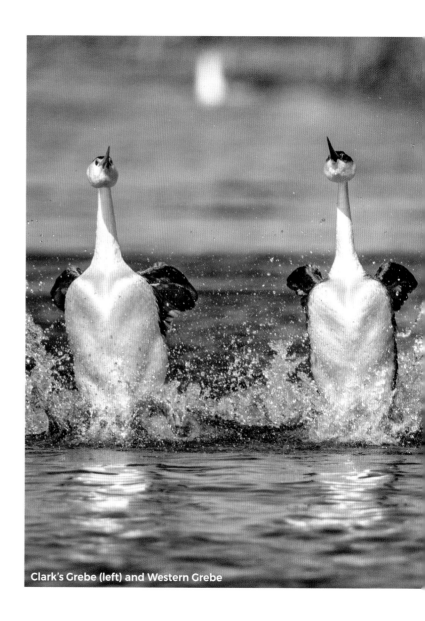

Clark's Grebe (left) and Western Grebe

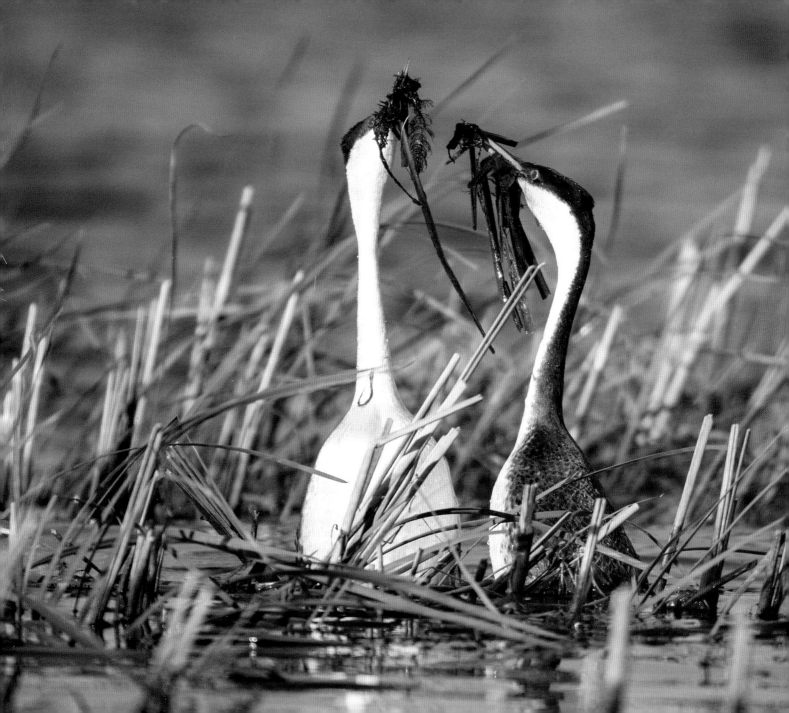

Western Grebe

When an established male and female perform a rush, it is often followed by another highly specialized display called a weed dance or weed ceremony. In a weed dance, a courting pair dives and comes back to the surface with small bunches of weeds in their bills. The partners swim toward each other with erect postures, raised crests on their heads, and weeds drooping from their bills. Once they meet, with their heads very close, they present their gift of weeds to each other and give a trilling call. Then they shake their heads back and forth, which often sends the weed offerings in all directions, effectively ending the ceremony.

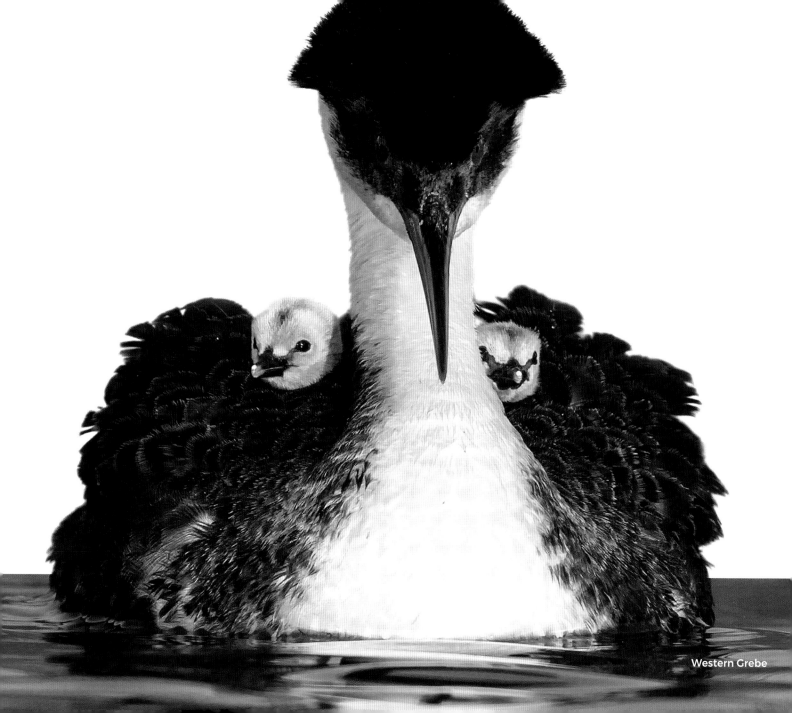

Western Grebe

What I enjoy most about Western and Clark's Grebes is that a brood of hatchlings will pile on the back of a parent and ride safely above the water. At other times, a parent will tuck 3-4 babies inconspicuously under its wings. The babies only poke their heads out at an opportune time—when the other parent arrives with a fish.

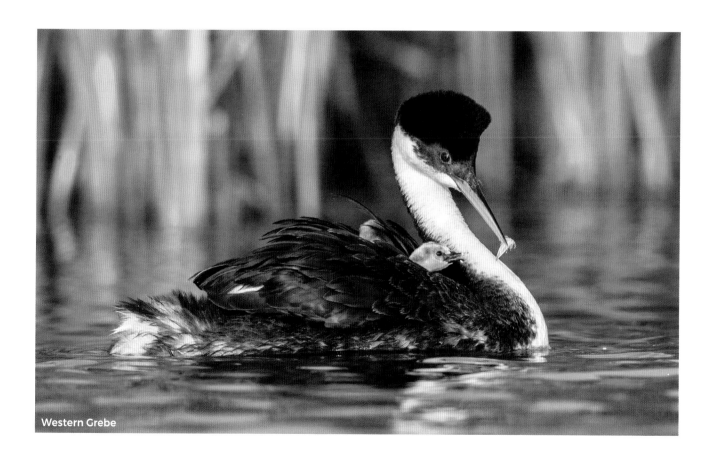

Western Grebe

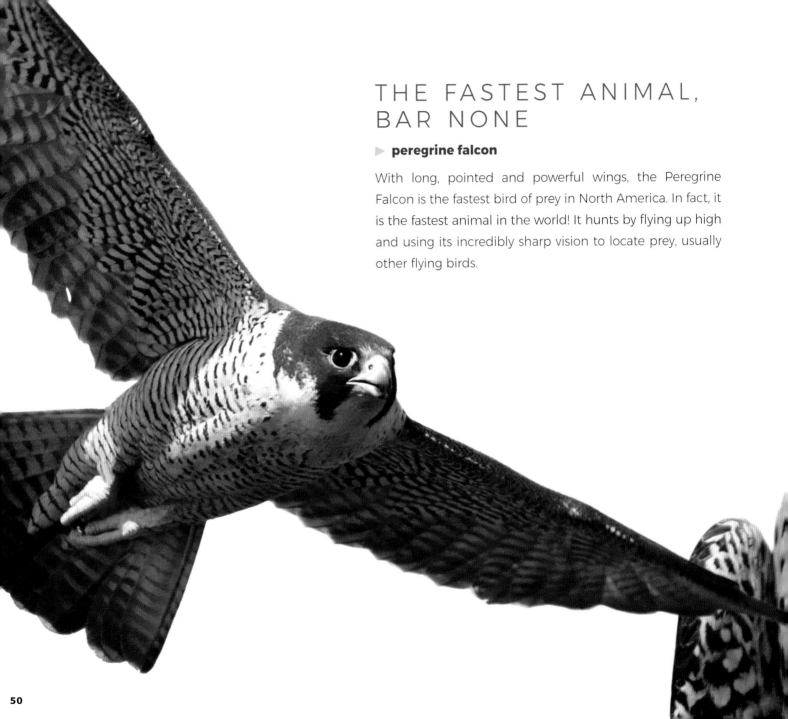

THE FASTEST ANIMAL, BAR NONE

▶ **peregrine falcon**

With long, pointed and powerful wings, the Peregrine Falcon is the fastest bird of prey in North America. In fact, it is the fastest animal in the world! It hunts by flying up high and using its incredibly sharp vision to locate prey, usually other flying birds.

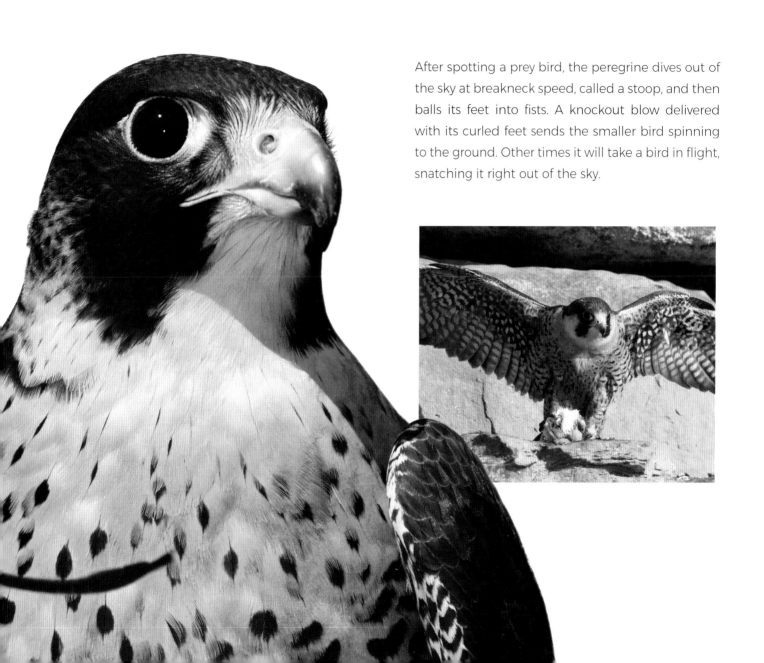

After spotting a prey bird, the peregrine dives out of the sky at breakneck speed, called a stoop, and then balls its feet into fists. A knockout blow delivered with its curled feet sends the smaller bird spinning to the ground. Other times it will take a bird in flight, snatching it right out of the sky.

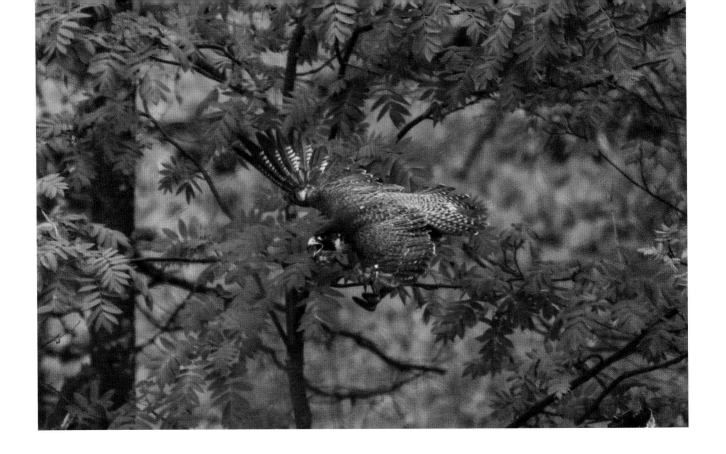

The normal cruising speed for peregrines is about 40–60 mph, but they can reach 150–175 mph in a dive. At these high speeds they run the risk of sustaining a severe injury upon impact with their prey. Many researchers believe that if the birds could go any faster, any slight miscalculation would send them spinning out of control.

The common name "Peregrine" is Latin and means "foreign" or "abroad." This lineage is why the bird is also known as the Wandering Falcon.

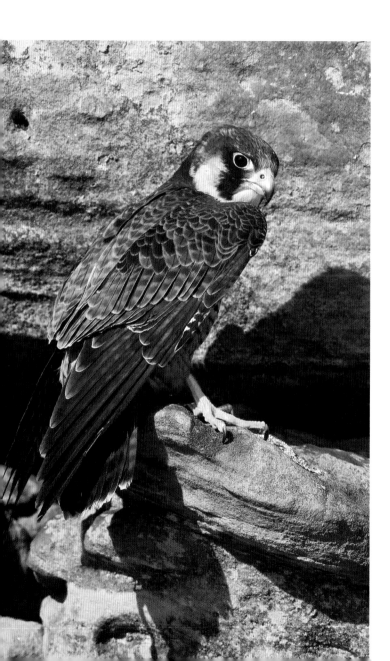

Peregrines are found on every continent except Antarctica. They breed in so many different kinds of habitat—from the Arctic to the tropics—that they are considered a habitat generalist. They are the world's most widespread raptor partly because they've been among the most popular raptors chosen for the ancient sport of falconry. For thousands of years, people have hunted with these birds. They have also bred them and moved them, expanding their range around the planet. As a result, it is generally thought that the number of peregrines is greater now than in the past.

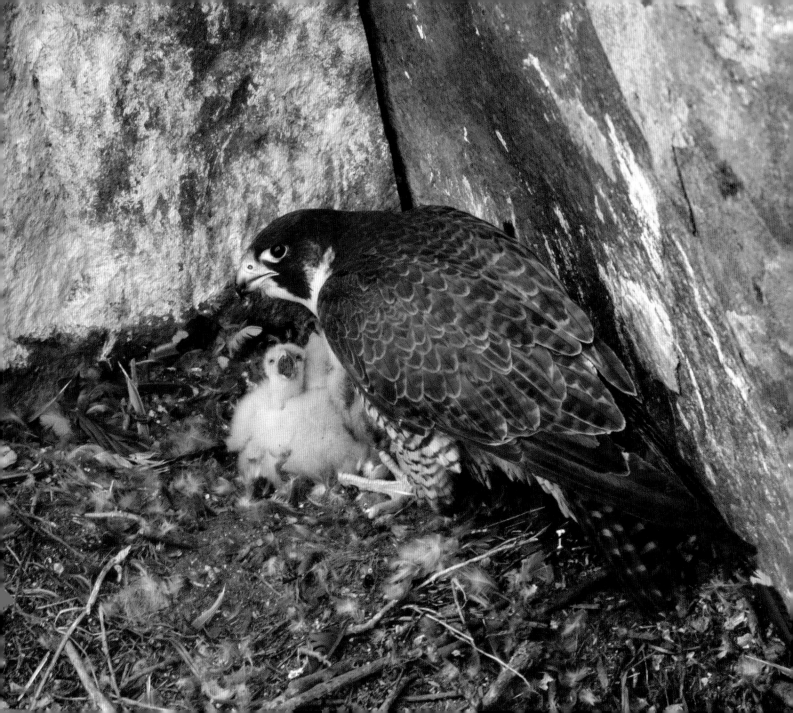

Peregrines reach sexual maturity at one year of age and often form long-term bonds with their mates. Well known for nesting on high cliffs, they have adapted very well to man-made nesting platforms on skyscrapers, smokestacks and other tall structures. Today, peregrines live and breed in most of our large metropolitan cities across the country, where they keep the pigeon populations in check. While they feed mainly on medium-sized birds, they also eat small mammals, small reptiles, and occasionally, larger insects.

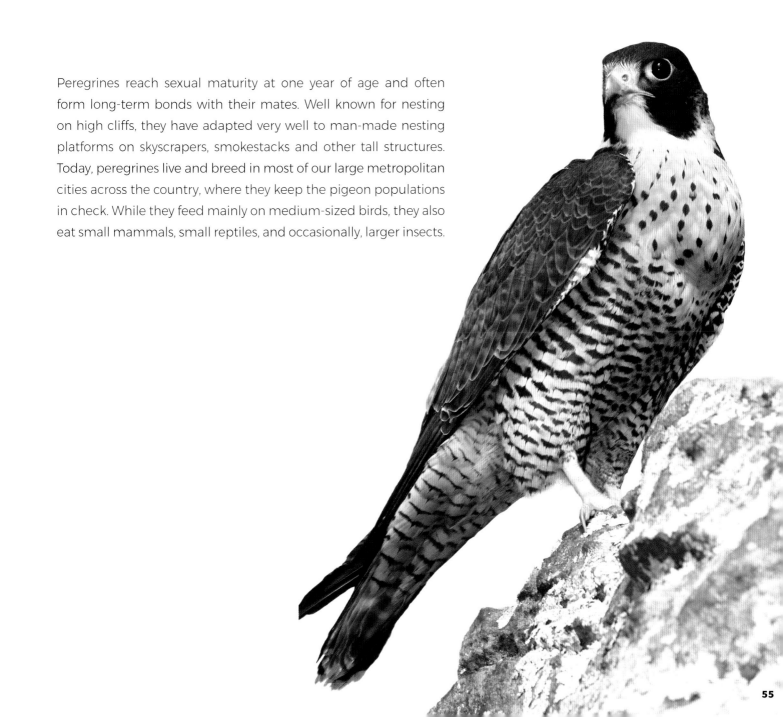

MEAT-EATING SONGBIRDS THAT DON'T SING

▶ **shrikes**

Gray and black and looking somewhat like a Blue Jay, shrikes are unlike all other songbirds. Instead of singing, they give a series of harsh, nonmusical phrases, repeating them over and over.

Shrikes have more in common with Peregrine Falcons than they do with songbirds. Shrikes are unusual because while they don't have large, powerful feet with long, sharp talons, they are predators that hunt small birds and mammals. Sitting on a high perch, they watch for an unsuspecting mouse, vole or shrew, or even a small bird. They swoop down, grasp the prey with their feet and hammer at it with their large, semi-hooked bill. Once the prey is incapacitated, they carry it off, usually to a storage spot, such as a thorn bush or barbed wire fence, where they impale it. Oftentimes they will come back later to feed.

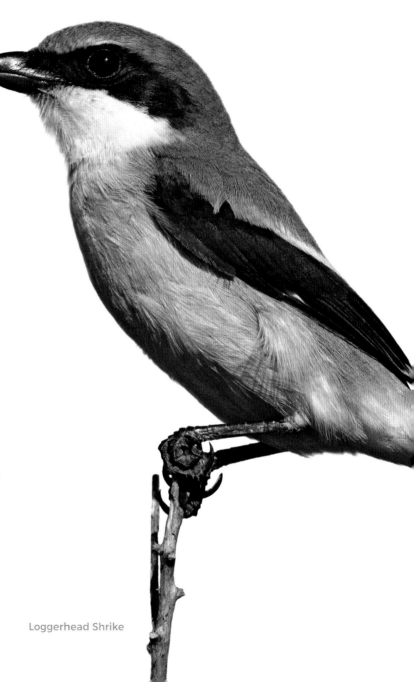

Loggerhead Shrike

Impaling prey on a stout thorn is why the shrike is also called the Butcher Bird. Shrikes probably impale a prey item to hold it steady while tearing it apart, because their tiny songbird feet are not capable of such a forceful task.

I have often seen shrikes catch voles and repeatedly throw them into the air. It seems strange that tossing voles can kill them, but it does. Once the voles are dead, the birds drape them over a spruce branch for later consumption. Shrikes are also known to charge into a backyard feeding station in hot pursuit of goldfinches, chickadees and other small birds.

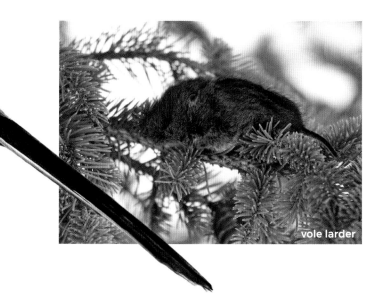

vole larder

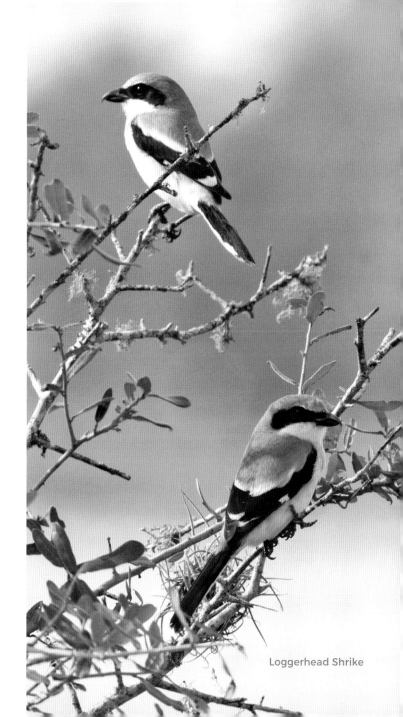

Loggerhead Shrike

There are only two shrike species in North America. The Loggerhead Shrike is much more widespread than the Northern Shrike, a winter visitor from Canada and Alaska. Their genus name, *Lanius*, means "butcher" and refers to the conspicuous behavior of impaling or skewering their prey on sharp objects, like thorns or barbed wire.

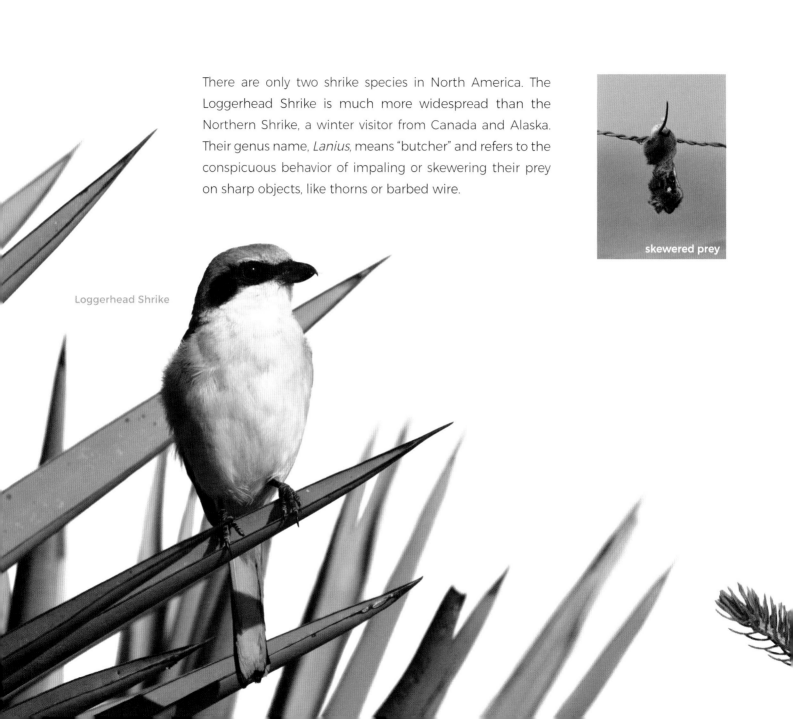

skewered prey

Loggerhead Shrike

Because both shrikes look very similar, many people have difficulty telling them apart. Each has a black band, or mask, across the eyes, but the Loggerhead's mask is wider than the Northern's. Both shrikes have a large black bill, with the upper bill ending in a sharp hook. The hooked bill is the business end of a shrike. Without it, it could not tear off the flesh of its prey.

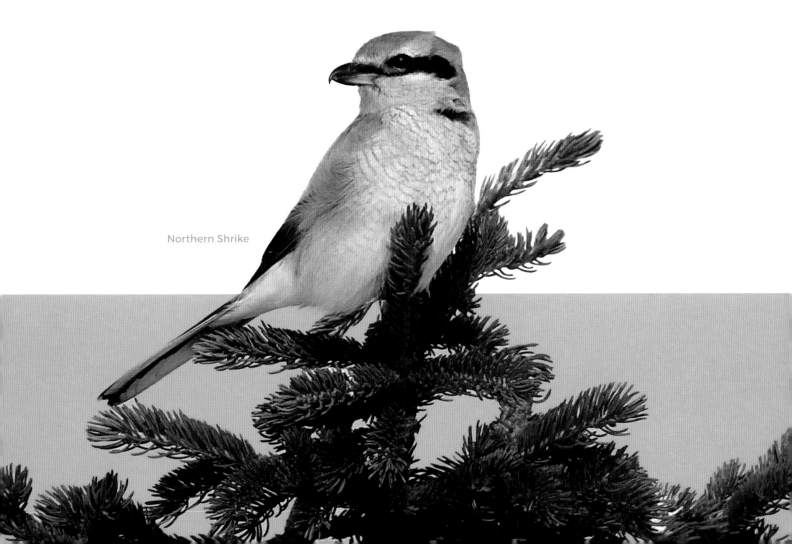

Northern Shrike

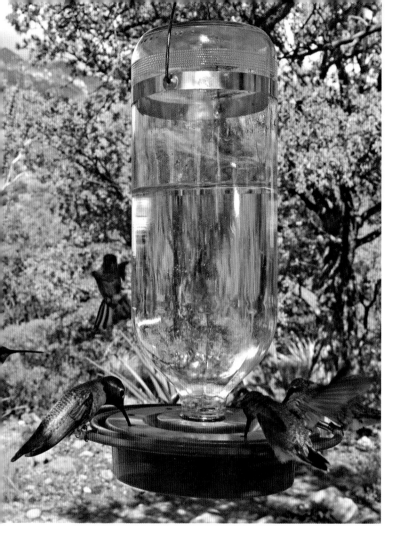

TINY CHAMPIONS OF FLIGHT

▶ hummingbirds

Hummingbirds, the tiniest of birds and masters of flight, have more than 300 species and comprise the second-largest family of birds in the world. They are unique to the Western Hemisphere, with a very limited distribution in North, Central and South America and the surrounding islands. In North America, we see 12 species consistently and upwards of 16 species due to other kinds of hummers flying into the United States from Mexico each year. The most widespread of these species is the Ruby-throated Hummingbird.

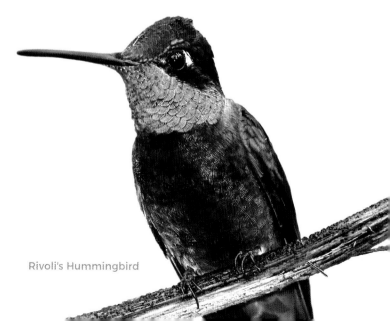

Rivoli's Hummingbird

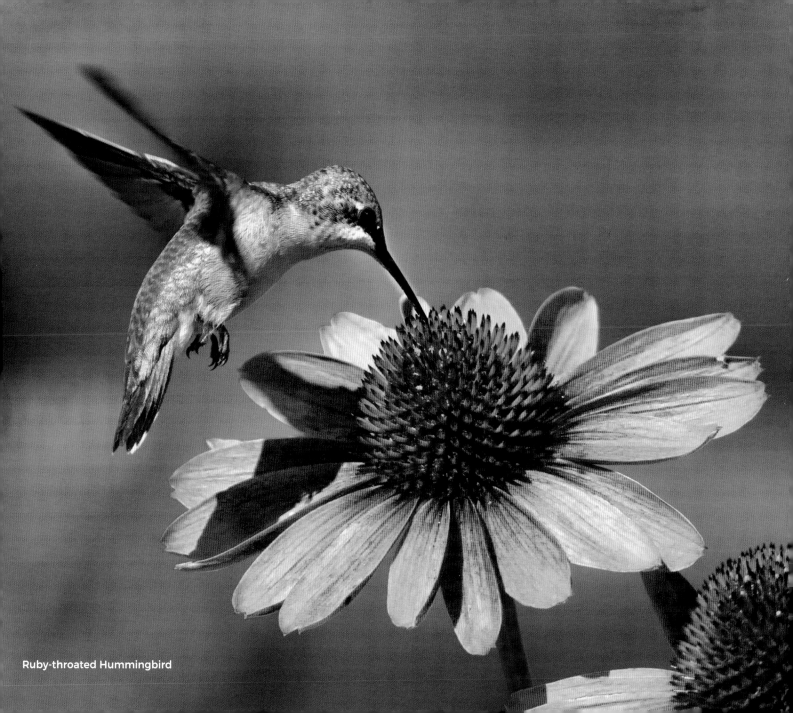

Ruby-throated Hummingbird

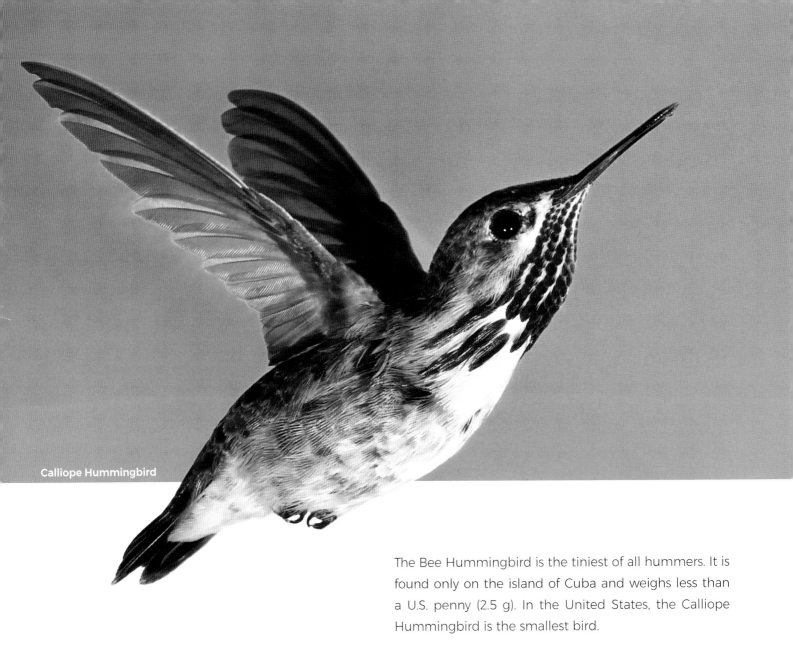

Calliope Hummingbird

The Bee Hummingbird is the tiniest of all hummers. It is found only on the island of Cuba and weighs less than a U.S. penny (2.5 g). In the United States, the Calliope Hummingbird is the smallest bird.

The Ruby-throated Hummingbird has the largest breeding range of any hummer in North America. It is found in a wide variety of habitats in the eastern half of the country and a good portion of Canada. The iconic ruby throat of the male gives the species its name.

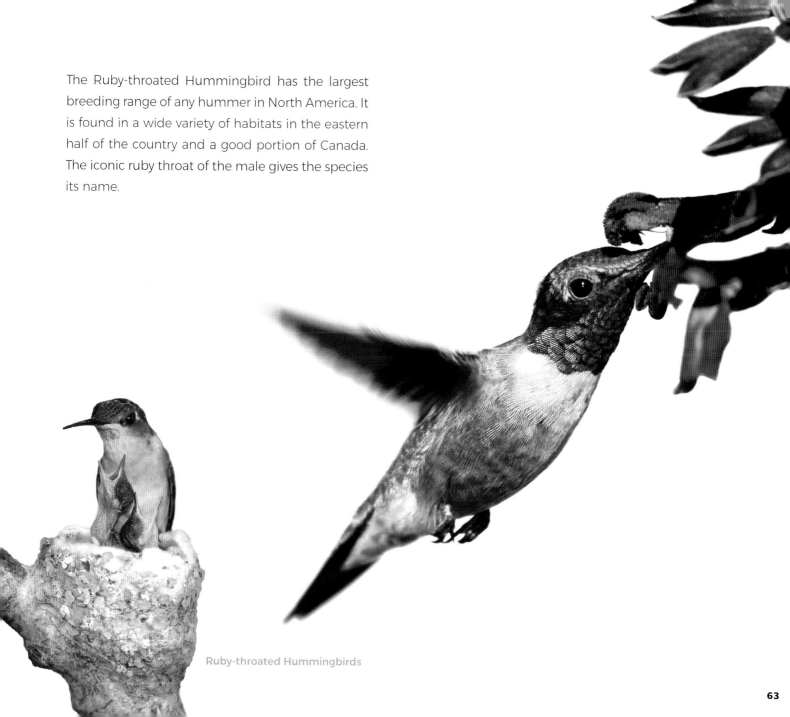

Ruby-throated Hummingbirds

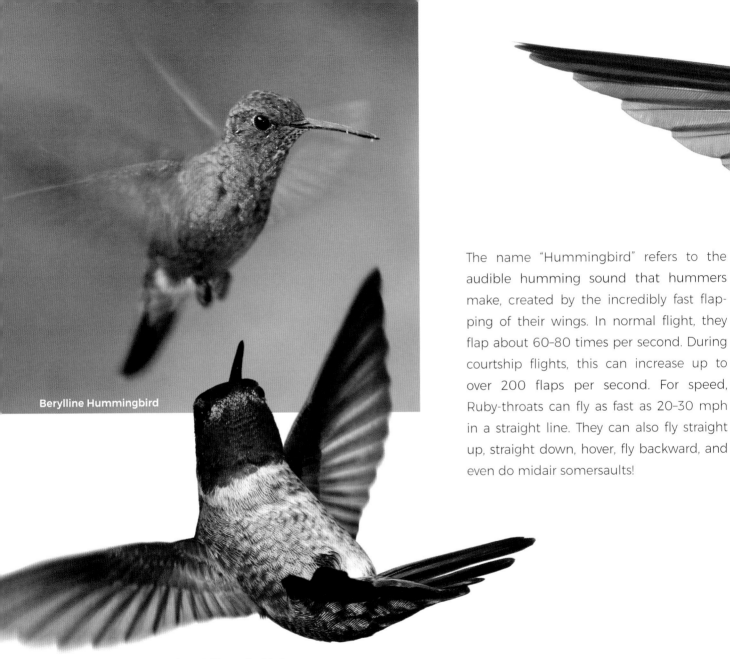

Berylline Hummingbird

The name "Hummingbird" refers to the audible humming sound that hummers make, created by the incredibly fast flapping of their wings. In normal flight, they flap about 60–80 times per second. During courtship flights, this can increase up to over 200 flaps per second. For speed, Ruby-throats can fly as fast as 20–30 mph in a straight line. They can also fly straight up, straight down, hover, fly backward, and even do midair somersaults!

Anna's Hummingbird

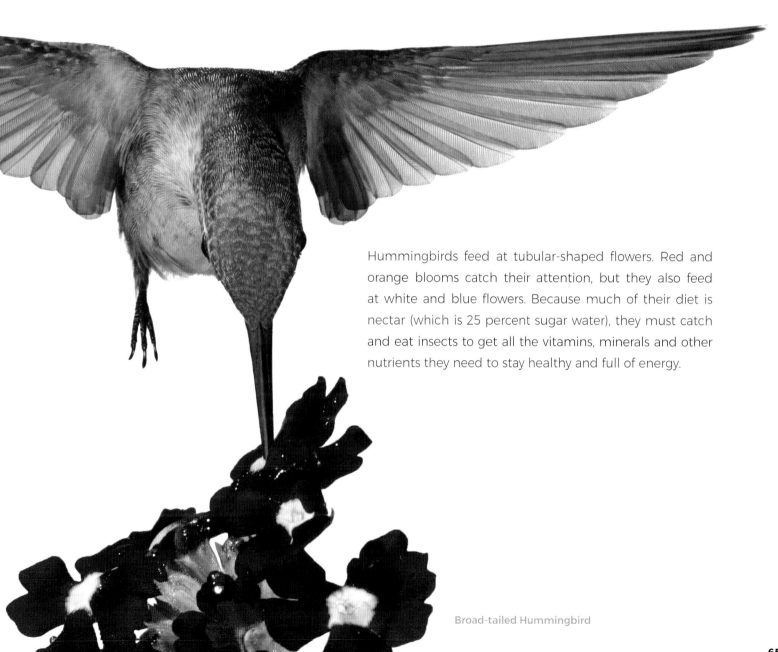

Hummingbirds feed at tubular-shaped flowers. Red and orange blooms catch their attention, but they also feed at white and blue flowers. Because much of their diet is nectar (which is 25 percent sugar water), they must catch and eat insects to get all the vitamins, minerals and other nutrients they need to stay healthy and full of energy.

Broad-tailed Hummingbird

Hummers have the highest metabolism of any warm-blooded animal on the planet, so during the daylight hours they are constantly looking for food. These birds are not very friendly toward each other, and fights and squabbles frequently break out around feeding stations. To conserve vigor, at night they enter a state of torpor, which is a kind of mini-hibernation that slows their metabolism to a fraction of the normal rate. This saves a lot of the energy they will need for the next busy day.

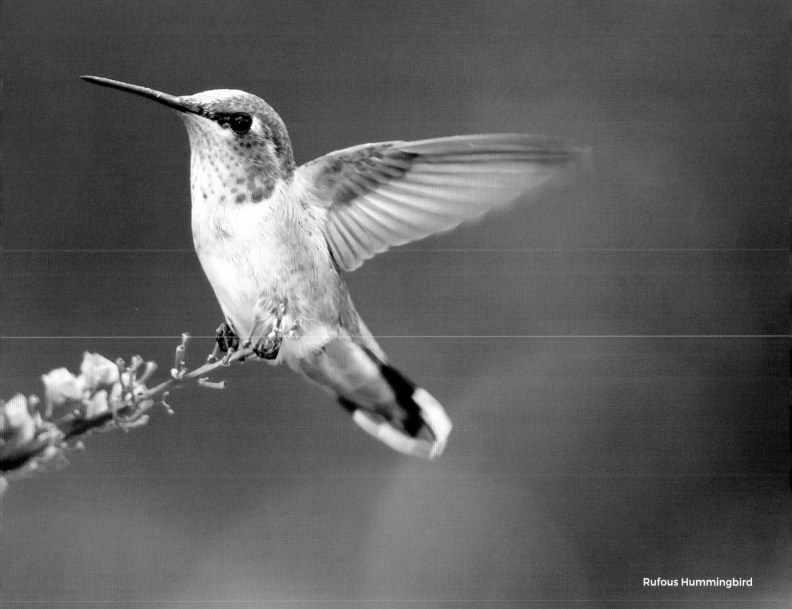

Rufous Hummingbird

THE BEST SHOW ON THE LEK

▶ **greater sage-grouse**

There are many strange and wonderful mating rituals in the bird world, but the strutting display of the Greater Sage-Grouse is extra special. Each spring, a group of males gathers on a traditional displaying ground, called a lek, to dance and show off to the females.

For a couple of hours early in the morning and again in the evening, the males assemble to fan their spiky tail feathers and droop their wings, striking an astonishing pose. Simultaneously, they inflate the yellow air sacs on each side of their necks while making a popping noise that sounds like water dripping. The best performers congregate at the center of the group, where the females watch intently and judge them. Studies show that the most dominant male will mate with upwards of 80 percent of the females that come to see the display on the lek.

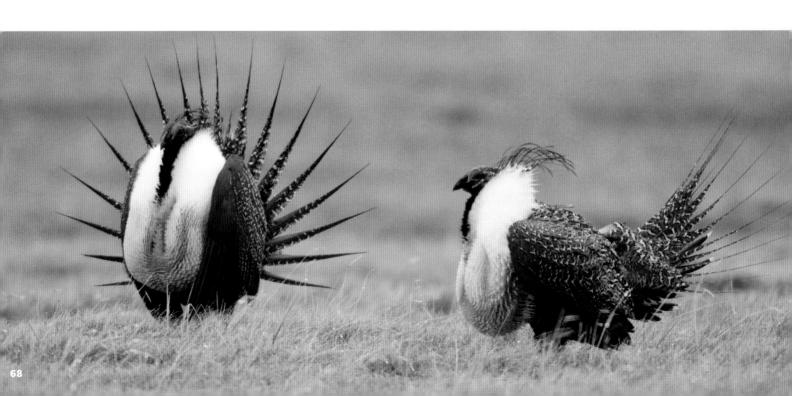

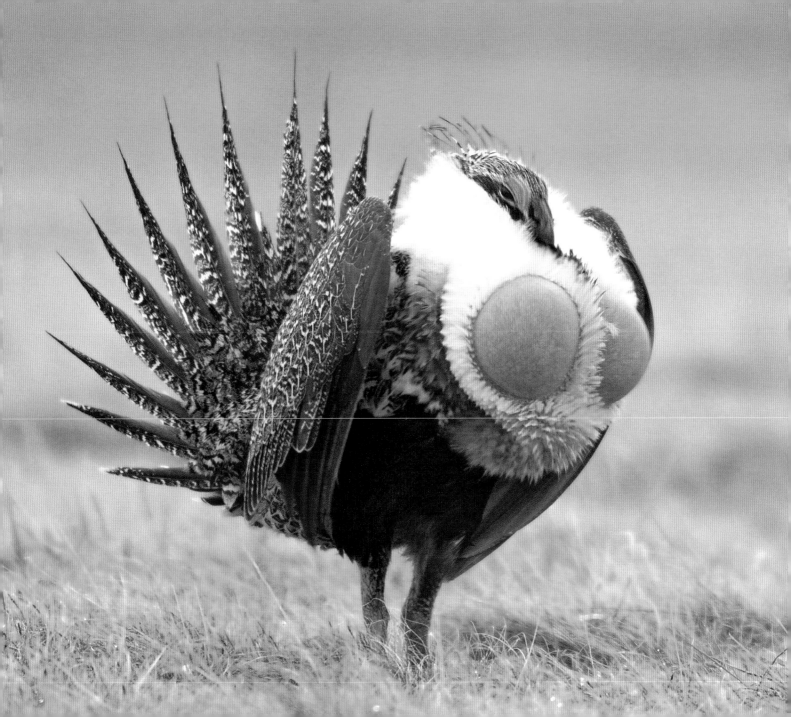

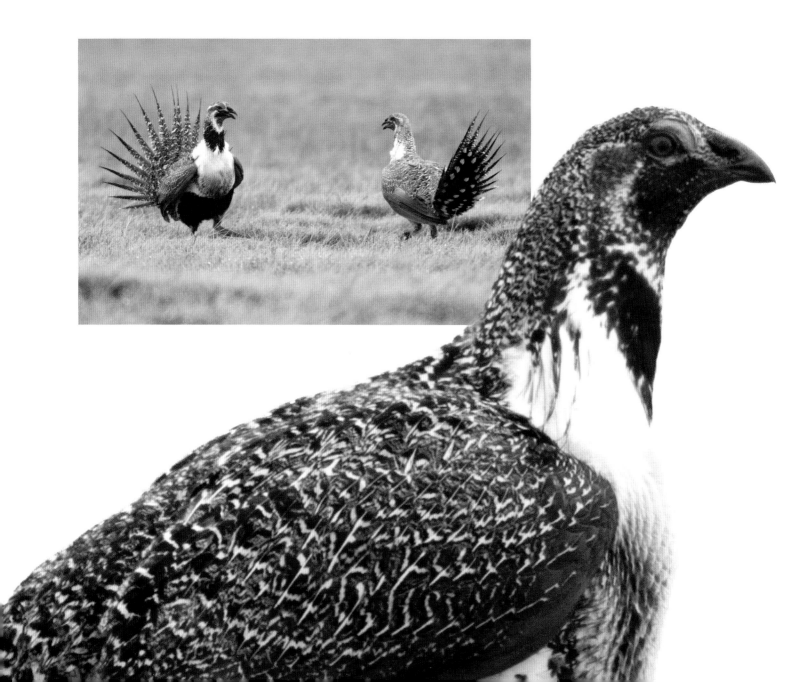

The Greater Sage-Grouse is the largest grouse species in North America. In fact, when you see these birds, one of your first reactions may be to think, "Wow! Those birds are huge!" When a dozen or more of the males draw together to display, it is a sight to be seen.

As the name suggests, this grouse lives in a habitat of vast, windswept, treeless plains dominated by large sagebrush. Historically, sage-grouse were found in 16 states and parts of 3 Canadian provinces. Between 1988 and 2012, the population declined by 98 percent. By 2013, they were gone from most of the states and much of Canada. Small pockets remain today, and many efforts to protect this vanishing species are underway. Only time will tell if in the future we will continue to hear the fluid popping sounds and admire the spiked tails of sage-grouse performing their dance on the lek.

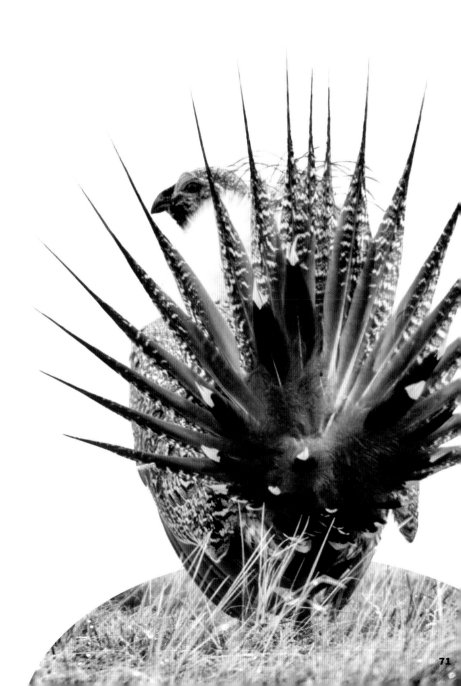

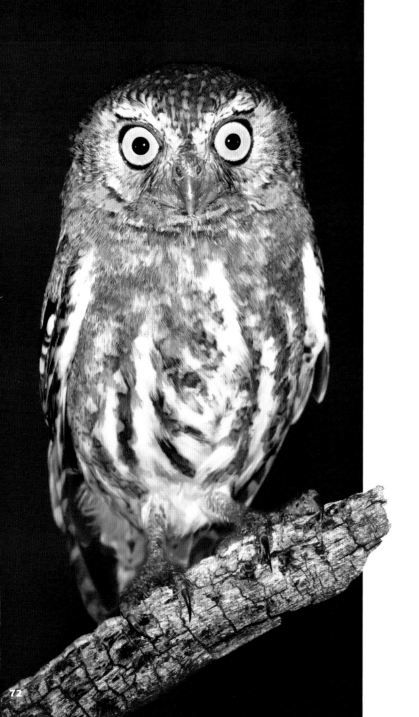

A RAPTOR SMALLER THAN A SPARROW

▶ **elf owl**

If owls are known for being mysterious and powerful, the Elf Owl just adds to the magic. The Elf is aptly named because it is the smallest owl in North America. Actually, it is the smallest owl in the world. Weighing only 1.4 ounces and standing a mere 5 inches tall, it is smaller than the average sparrow!

After spending the winter in Mexico, Elf Owls migrate to nesting grounds in the southern parts of Arizona, New Mexico and Texas. These tiny raptors usually lay eggs and raise their families in old woodpecker cavities. Often an Elf Owl cavity will be in a small tree or saguaro cactus.

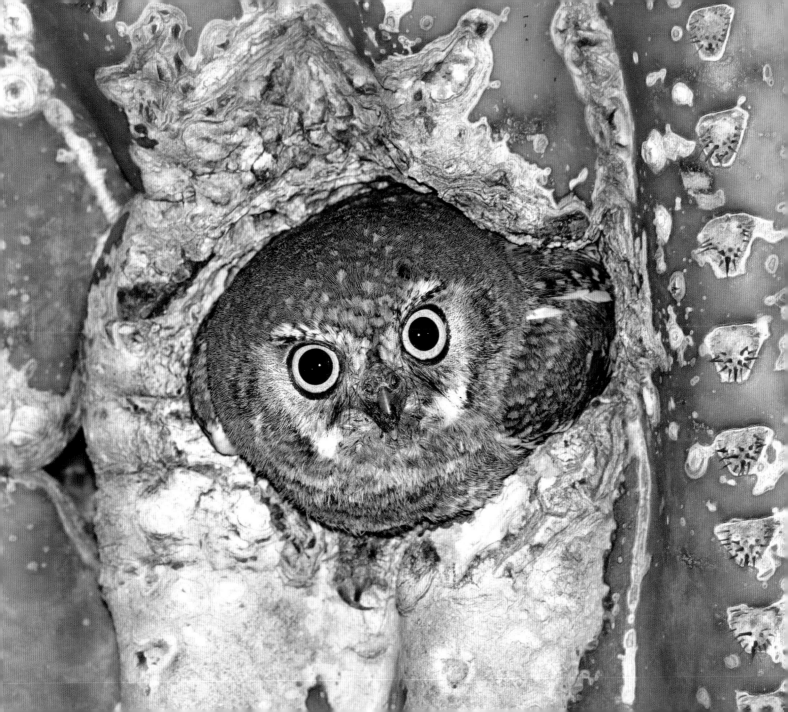

Fierce hunters, Elf Owls chase down June bugs, beetles and crickets, and often pursue flying insects, such as moths. Occasionally they will catch scorpions and don't seem to be affected by the sting.

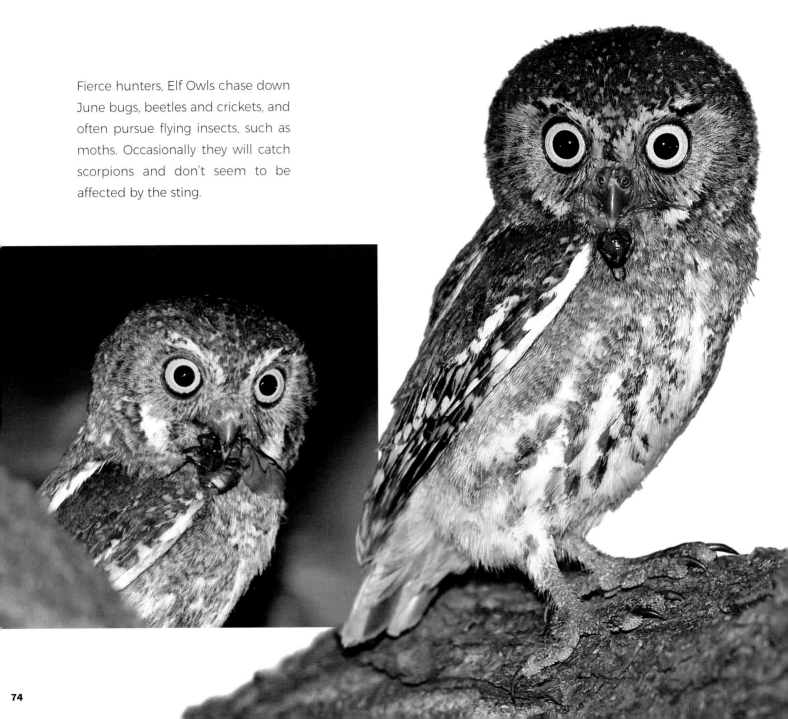

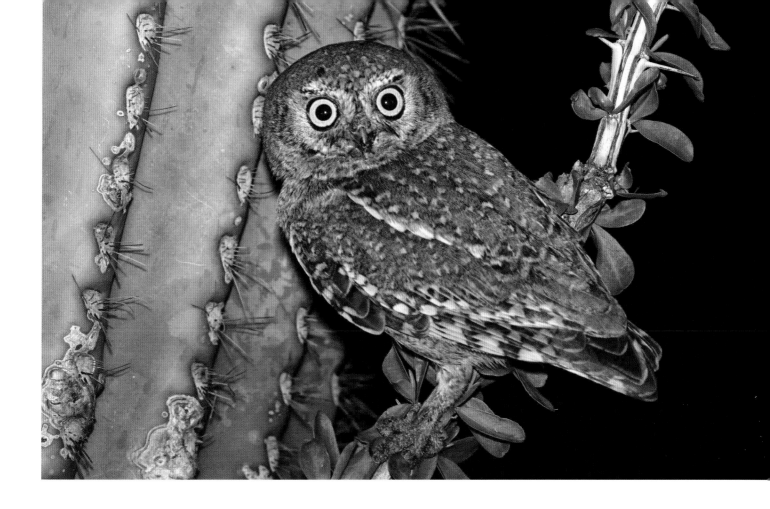

Elf Owls are fairly vocal and can be heard calling to one another just after dark. They have excellent eyesight in low light and exceptional hearing, both of which aid in finding prey in the dark. Like other owls, they fly silently due to special feather adaptations.

When threatened, Elf Owls play dead or fly away as fast as they can. Being so tiny, these owls need to be careful around larger owls, which can easily snatch them up and have them for dinner.

INCREDIBLY FUNNY-LOOKING SEABIRDS

▶ puffins

Puffins have got to be some of the more funny-looking birds in the bird world. We have three puffin species in North America—the Atlantic Puffin, the Horned Puffin and the Tufted Puffin.

When most people think of puffins, they visualize Atlantic Puffins. As the name implies, these birds inhabit the islands and coasts of the North Atlantic Ocean. Horned and Tufted Puffins are found along the coast of the North Pacific Ocean, extending from British Columbia to the Aleutian Islands of Alaska.

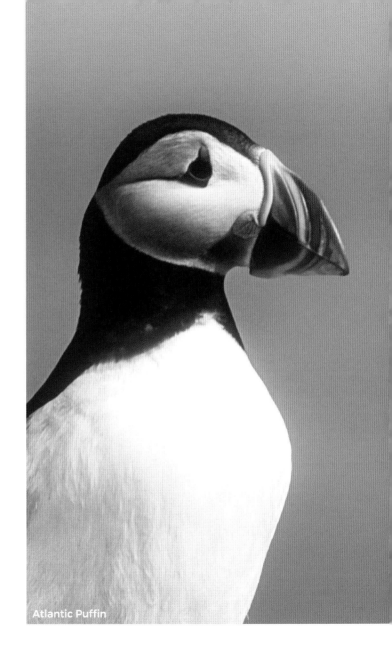

Atlantic Puffin

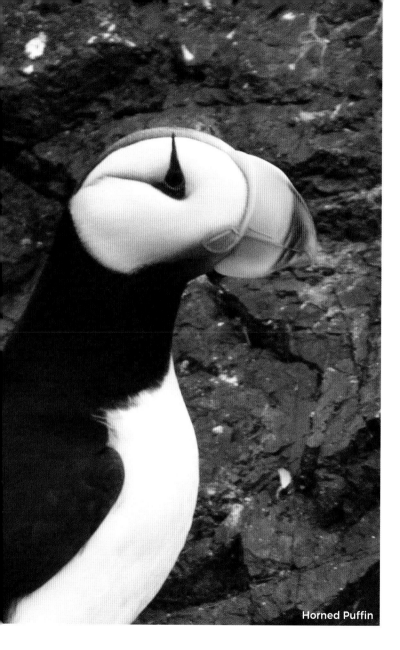

Horned Puffin

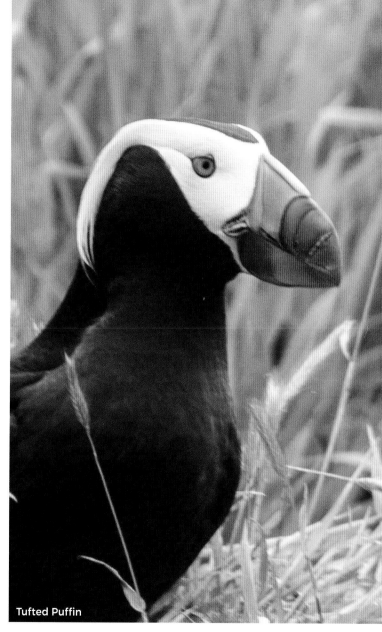

Tufted Puffin

Puffins are pelagic seabirds. This means they live 90 percent of their lives in the open waters of the ocean. They only come to land to breed in large colonies on coastal cliffs or islands. Unlike many other birds, puffins nest in rock crevices and cracks or in shallow burrows in the soil. It's odd that a bird that spends most of its life swimming would nest in places such as these, but this just adds to its peculiar appeal.

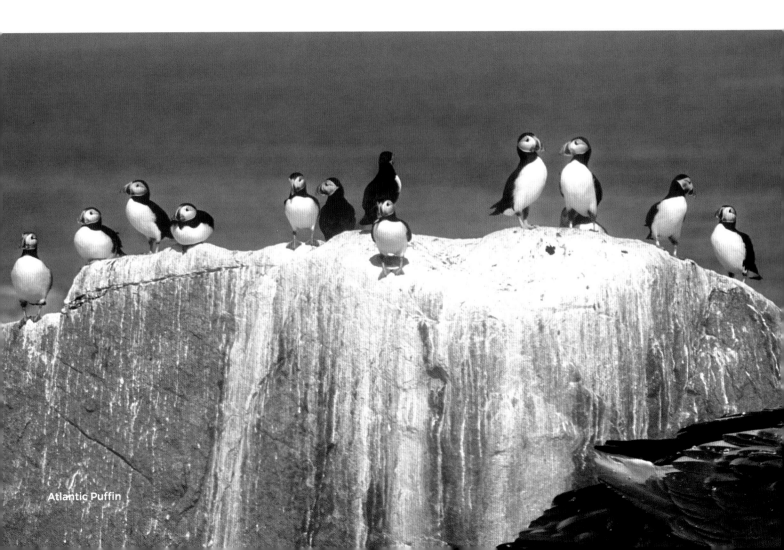

Atlantic Puffin

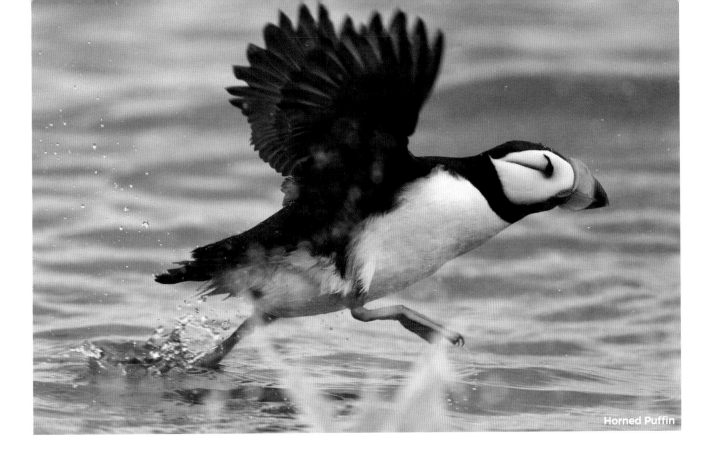

Horned Puffin

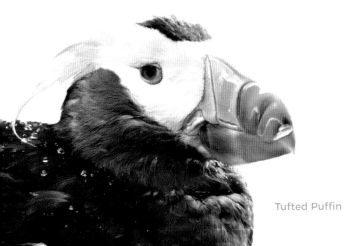

Tufted Puffin

Like many other pelagic seabirds, puffins are mainly black and white. They have short, round wings that enable them to get airborne during running takeoffs and to "fly" underwater when chasing fish. When flying in the air, they flap an amazing 300–400 beats per minute! Most flights are low and over the water's surface. Afterward, they fly up to the cliffs, where their nests are located.

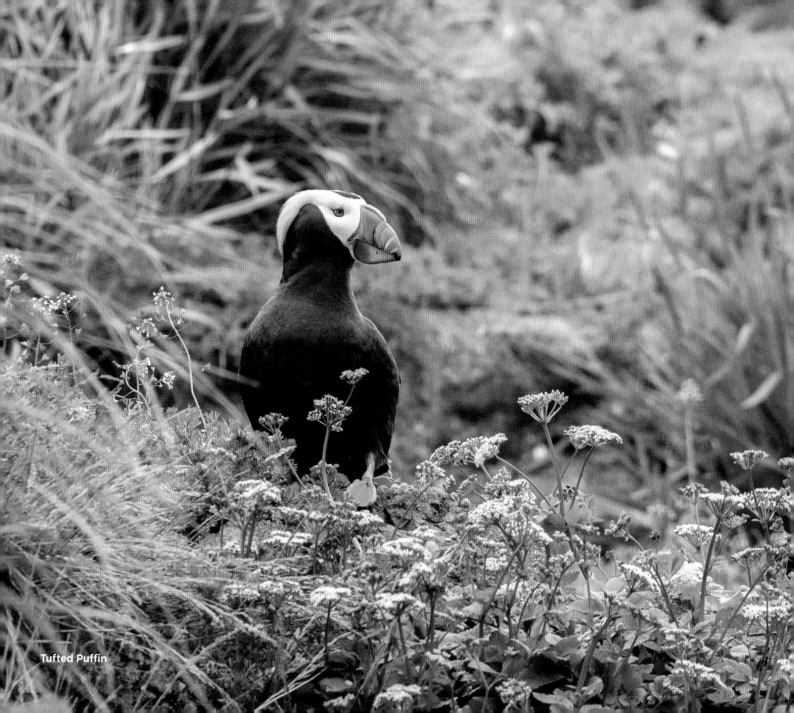

Tufted Puffin

All three puffin species are small, only 12–15 inches. They have orange feet and large, brightly colored bills. During the mating season, they use their dynamic bills to impress a mate. When the season ends, the colorful bill is shed, leaving a smaller and duller, more utilitarian bill.

The name "Puffin" comes from an Old Middle English word for the cured bodies of edible seabirds. In some parts of the world, such as Iceland, puffins are still hunted and eaten, just as they were in the distant past. Along Maine's coast, puffins were at one time common, but they were nearly wiped out due to hunting and egg collecting in the 1800s.

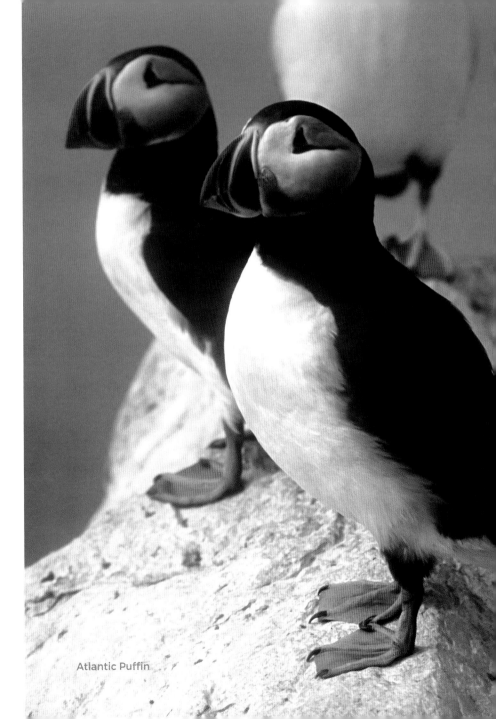

Atlantic Puffin

Until very recently, not much was known about where puffins went after the breeding season. Modern scientists affixed tiny geolocators to several puffins to track their locations. It was discovered that they moved northward into the Gulf of Saint Lawrence before heading south from the Labrador Sea to Bermuda during the winter. They spent more than eight months resting, feeding and sleeping at sea, far from any land—making them not just interesting-looking, but also incredible little birds indeed.

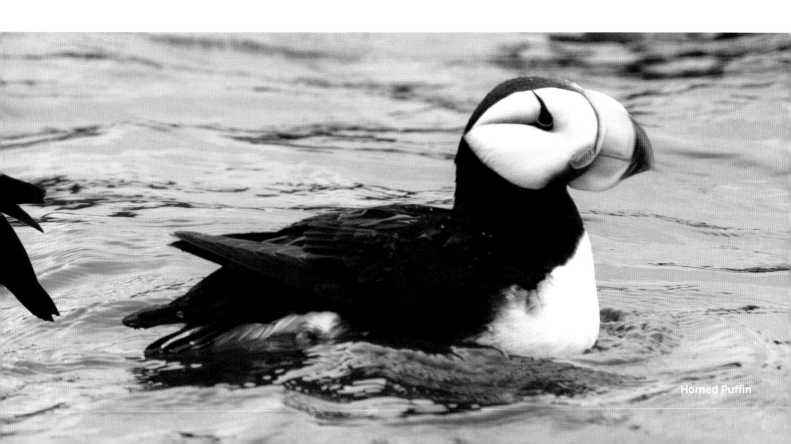

Horned Puffin

TIMBERDOODLE
SKY DANCING

▶ **american woodcock**

The American Woodcock is among the few birds that perform a complex aerial display to attract a mate. This small, plump bird, also known as the Timberdoodle, is actually a type of shorebird that, oddly enough, lives a long way from the shore throughout the eastern half of the country.

Woodcocks are long-distance migrators that make the trip from northern states to southern states for the winter. Each spring, they fly back to their displaying grounds—the very same places that many woodcocks before them returned to over past generations.

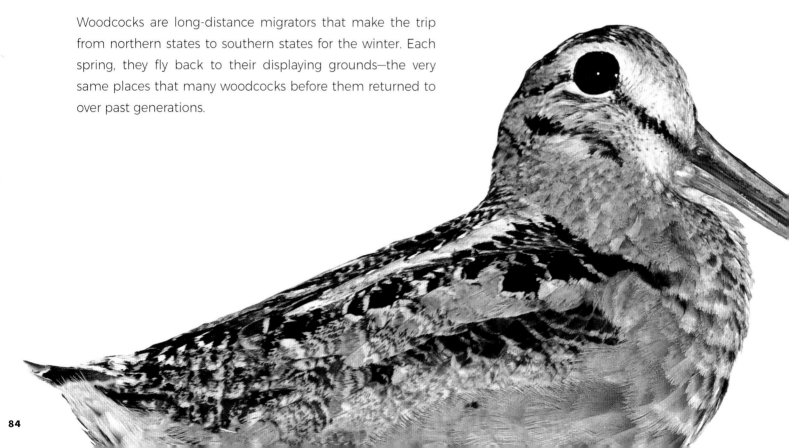

About 20 minutes after sunset, the males move into the open, grassy fields to display in the dark. Each male starts with a loud "peent" call and repeats it at regular intervals about 2–3 seconds apart. Then, in the glow of the setting sun, the male takes to the sky in one of the most spectacular airborne displays. Rising in a slow, wide, circular flight pattern into the evening sky, the male makes a twittering noise that sounds like he's vocalizing, but it's actually created by his narrow flight feathers cutting through the air.

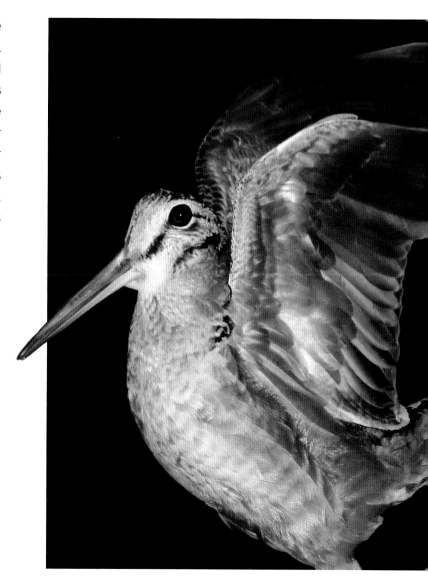

Once the male reaches about 200–300 feet in altitude, he flies in circles, all the while giving a series of twittering pops and pings. Meanwhile, back on the ground, the females are watching the Timberdoodle sky dance and judging the male as a possible mate.

After making 2–3 circles in the night sky, the male suddenly folds his wings—immediately ending his twittering sound—and rockets to the ground, often landing very close to the spot where he originally took off. At this point he starts to strut around, giving his "peent" call over and over again. This goes on for about 20 minutes, after which the dark sky falls silent. If a female chooses him, they often fly off together into the nearby woods for a brief encounter. Afterward, the male returns to the displaying ground.

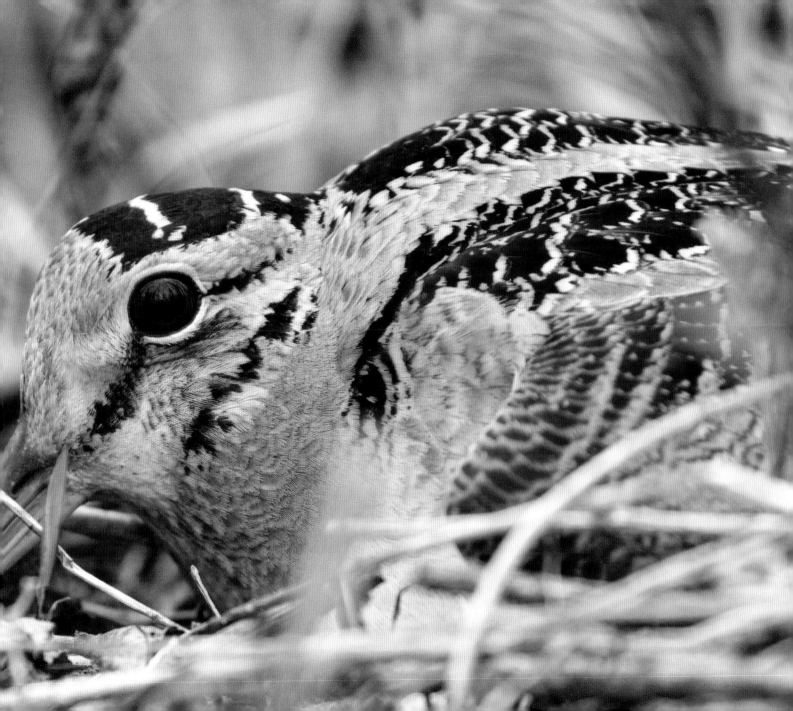

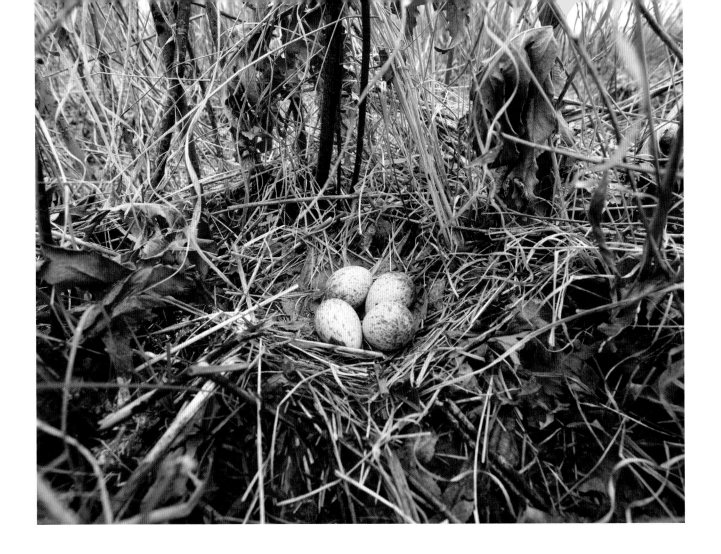

Woodcocks are so well camouflaged that you can be standing just a few feet away and still not see them. Females nest on the ground, making them vulnerable to predators, so their cryptic coloring is vital. Babies follow their mothers around within hours of hatching and are also well camouflaged.

The American Woodcock is the only woodcock species in North America. Unfortunately, its population has decreased due to habitat loss and overhunting.

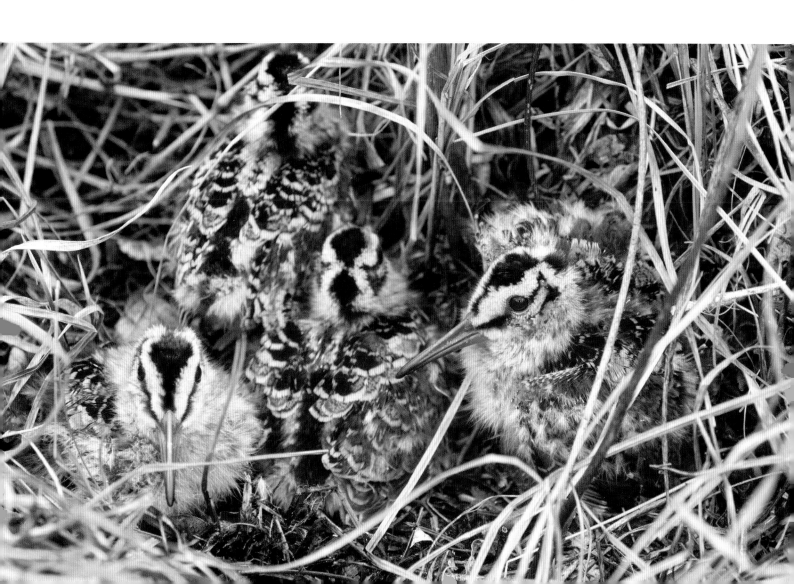

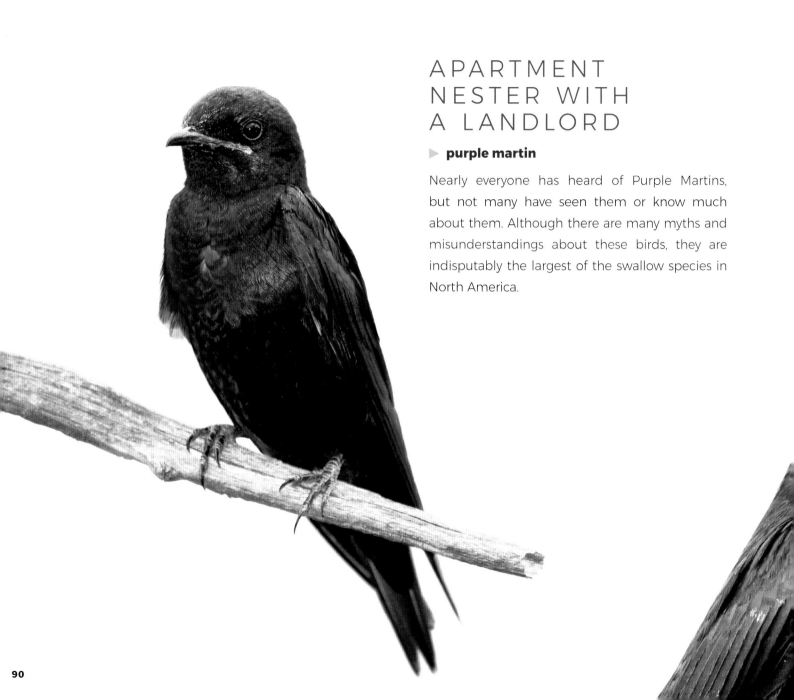

APARTMENT NESTER WITH A LANDLORD

▶ **purple martin**

Nearly everyone has heard of Purple Martins, but not many have seen them or know much about them. Although there are many myths and misunderstandings about these birds, they are indisputably the largest of the swallow species in North America.

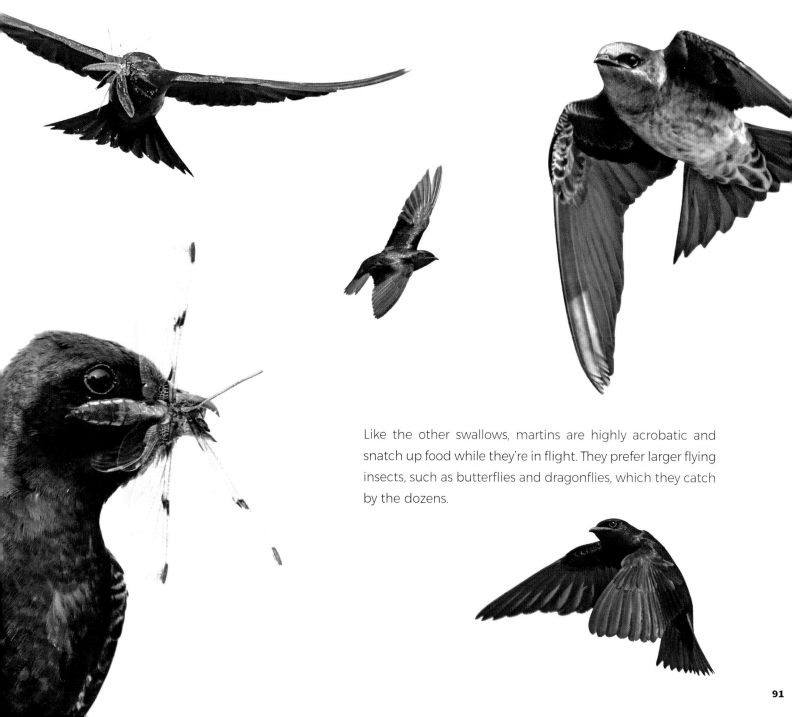

Like the other swallows, martins are highly acrobatic and snatch up food while they're in flight. They prefer larger flying insects, such as butterflies and dragonflies, which they catch by the dozens.

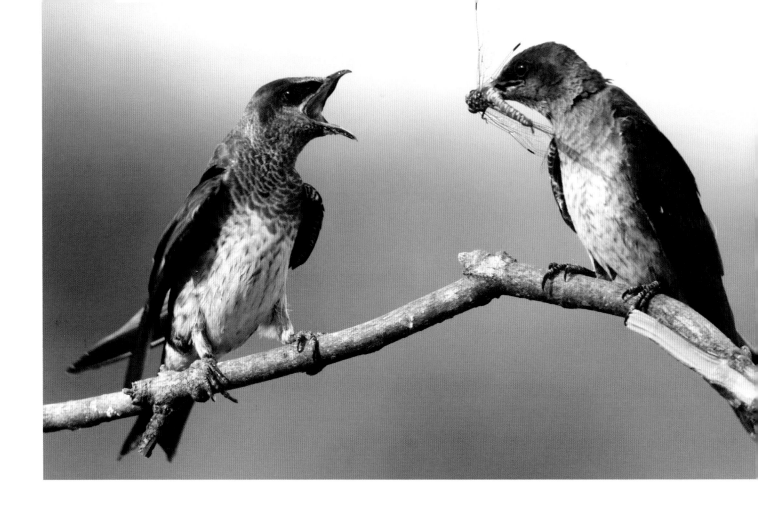

Over a century ago it was reported that martins would be extremely beneficial to have around because they would help reduce mosquito populations. As a result, in the early to mid-1900s, people made concerted efforts to attract as many martins as possible by providing them with housing complexes. The accommodations were so successful that it was believed that all martins east of the Mississippi River, which previously nested individually in natural cavities, were now nesting in colonies in these housing complexes.

The multiunit, apartment-style houses became widely popular throughout the martin's expanding range. But over time, people lost interest in supplying the housing, and Purple Martin populations declined dramatically. By the 1980s, populations were at all-time lows. Combined with the growing numbers of European Starlings and House Sparrows that were competing for the houses, the martins entered into crisis.

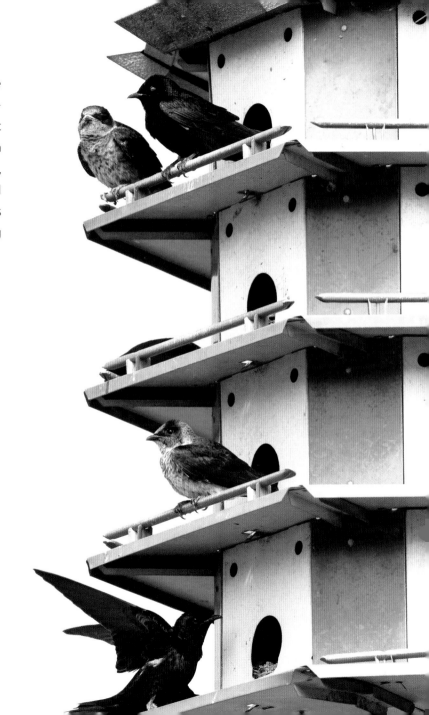

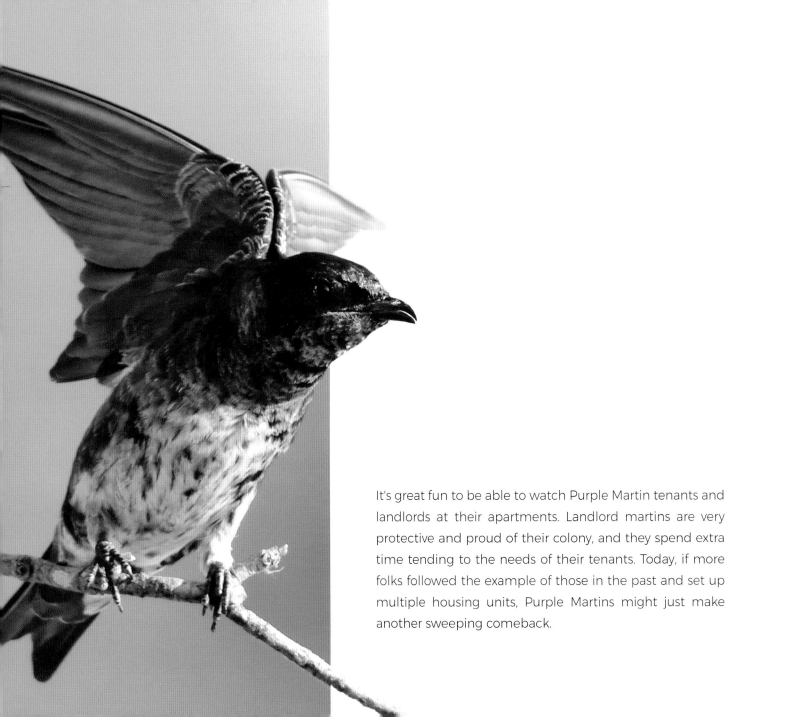

It's great fun to be able to watch Purple Martin tenants and landlords at their apartments. Landlord martins are very protective and proud of their colony, and they spend extra time tending to the needs of their tenants. Today, if more folks followed the example of those in the past and set up multiple housing units, Purple Martins might just make another sweeping comeback.

Purple Martins are highly migratory and winter in South America. Current studies show that most travel to Brazil from their range in the eastern two-thirds of the United States and the California coast. They migrate in large flocks during the day, feeding along the trip. In January, the birds arrive back in southern Texas and Florida, but they don't make it up to northern-tier states until May. Males often arrive first, followed shortly afterward by the females and the young from the previous year.

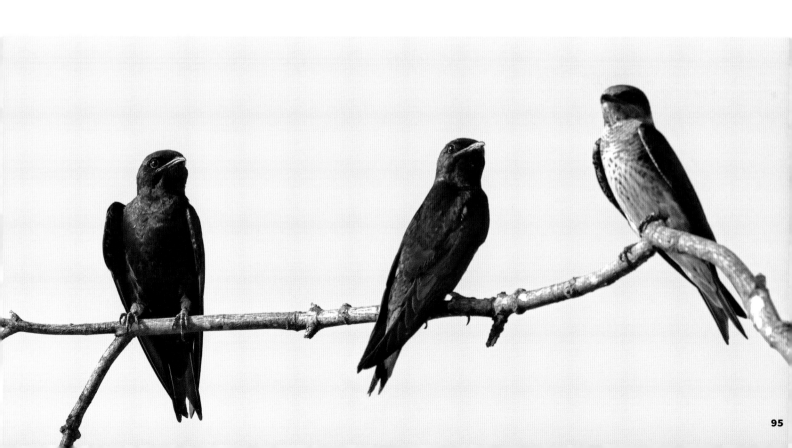

LAYS A QUICK EGG—THEN LEAVES!

▶ **brown-headed cowbird**

Often when we think about songbirds, an image comes to mind of a nest with several cute baby birds and an attentive mother and father feeding and caring for them. The Brown-headed Cowbird is a songbird with unusual reproductive behavior and is the exception to the typical bird family rule.

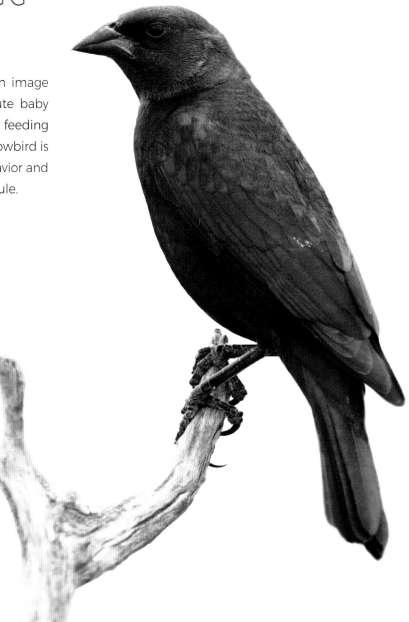

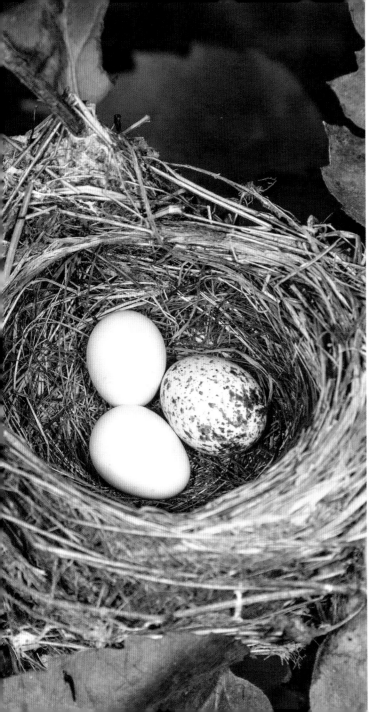

Cowbirds are nest parasites—which means the female doesn't build her own nest. Instead, she looks for the nests of other birds, particularly cup nests, swiftly lays a speckled egg, and then takes off, leaving the host parents to incubate and raise her chick along with their own babies.

Cowbird eggs have been documented across a variety of nest types, from the tightly woven nests of hummingbirds to the bulky stick nests of raptors. It has also been recorded that cowbird eggs were laid in the nests of over 220 species of birds, and more than 140 of these other species hatched and raised a cowbird chick.

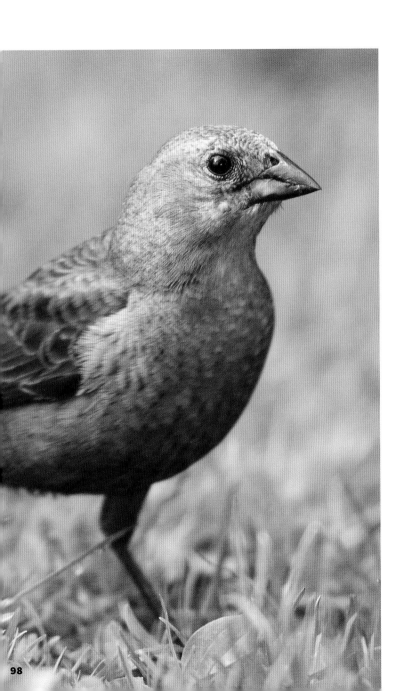

A single female cowbird can lay an incredible number of eggs—upwards of 40 in one season! What's more, she draws all of the calcium needed to produce this many eggs from her own bones.

Other cowbird species in North America are the Bronzed Cowbird and Shiny Cowbird. Only the Brown-headed has a large range. Bronzed and Shiny Cowbirds have very limited ranges in the extreme southwestern part of the country. All three species are the only nest parasites in North America.

Cowbirds are blackbird family members that prefer open and edge habitats. They travel around in flocks, even during the breeding season. Often they are found in mixed flocks with Red-winged Blackbirds, European Starlings and Common Grackles.

One of the most remarkable things about cowbirds is that when the young grow up in the nests of other species, such as Chipping Sparrows, they aren't exposed to the songs of their cowbird parents. Regardless, cowbird babies still develop cowbird songs, calls, and feeding and breeding behaviors instead of those of their adoptive parents.

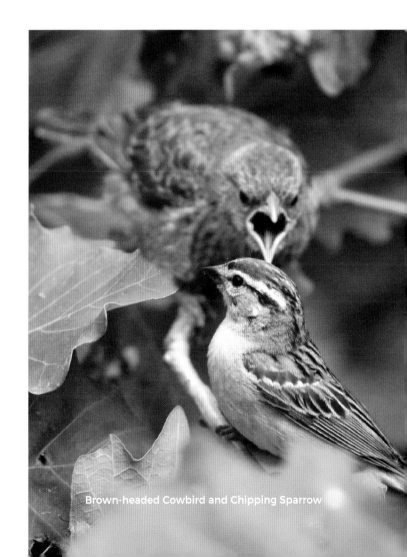

Brown-headed Cowbird and Chipping Sparrow

AN OWL IN A BURROW?

▶ **burrowing owl**

There are nearly 20 species of owls in North America. Each is unique and interesting enough to be called out on its own, but only one nests underground in a burrow. Aptly named, the Burrowing Owl is a tiny owl with exceptionally long, naked legs. It occurs throughout the western half of the country and has a separate population in southern Florida.

Burrowing Owls prefer open grassland and desert habitats. It is believed that prior to the settlement of North America, these owls inhabited all open regions of the country. But just as prairie dogs and other ground-dwelling critters were nearly eliminated due to the influx of domestic cattle, Burrowing Owl populations were also greatly reduced. Today, because their special habitats are becoming rare, these owls have declined further as well.

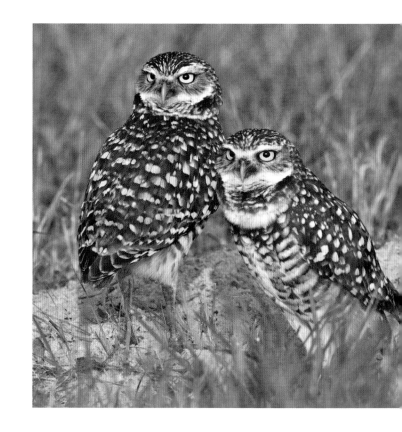

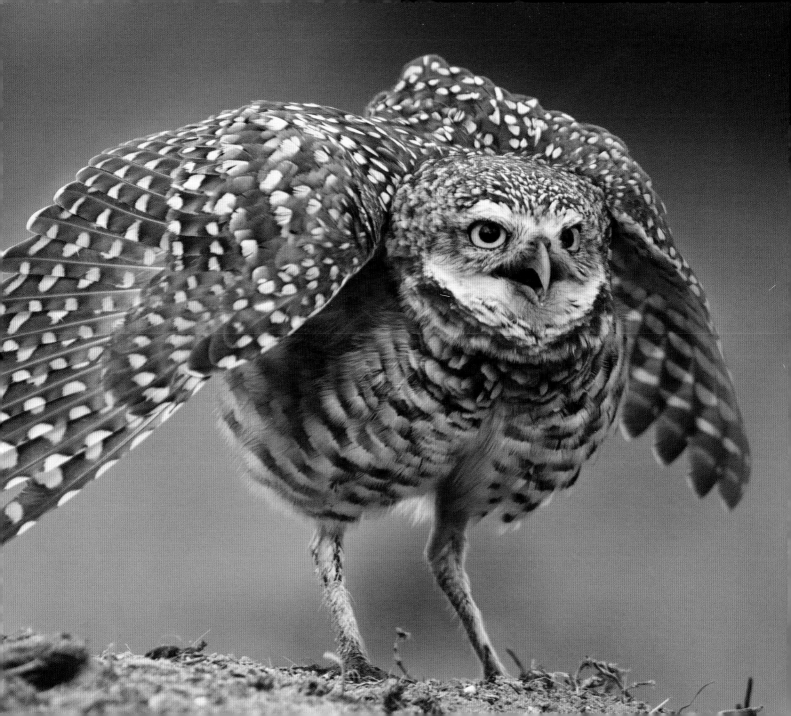

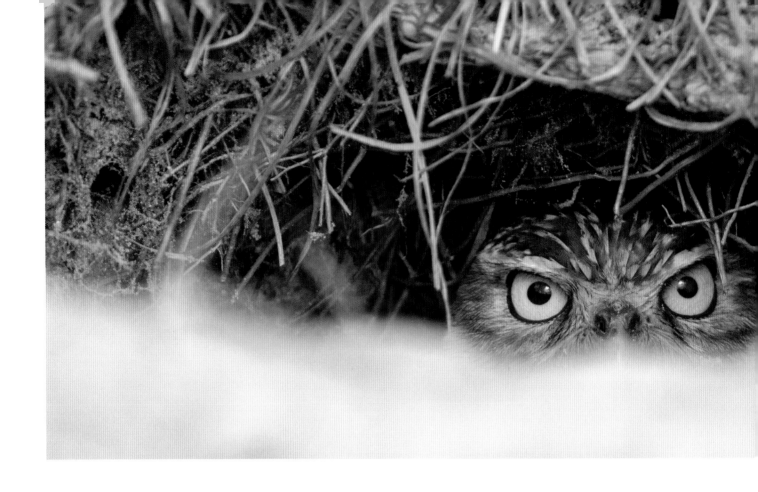

Most times, Burrowing Owls will take over an old squirrel hole or other ground-dwelling animal burrow. In some areas where the soil is looser, the owls dig their own burrows. Either way, they expand and repair their burrows on their own.

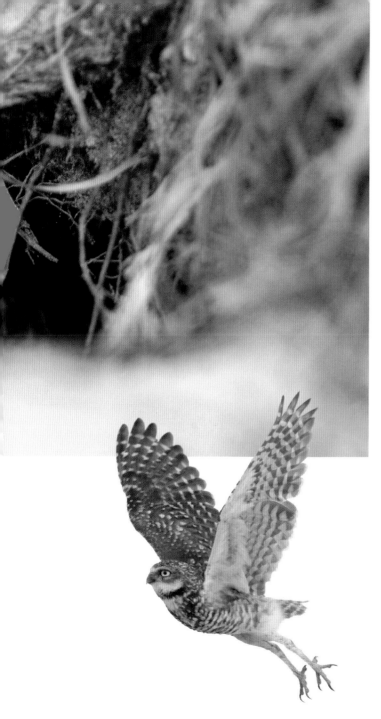

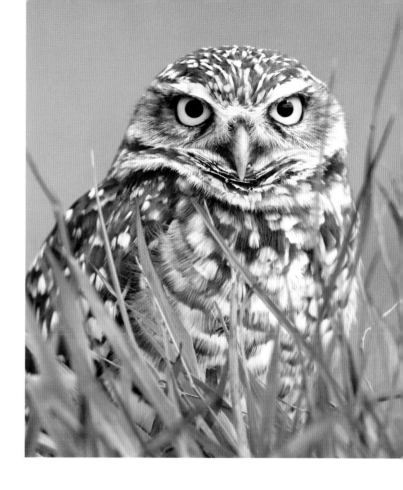

Burrowing Owls tolerate people fairly well and often nest in suburban neighborhoods, airports, parks and golf courses. They also take well to man-made underground nesting chambers. Many people have installed nesting burrows, and neighborhood associations promote Burrowing Owl nesting in open spaces. In these locations, they are often easy to observe.

When threatened, Burrowing Owls run quickly into their burrow and give a hissing or rattling sound, like that of a rattlesnake. This behavior is called acoustic mimicry and has the effect of driving off predators that don't want to tangle with an apparent venomous snake.

During the nesting season, pairs gather materials for the nest. Mates often bring in clumps of horse manure or cow dung and leave it at the nest entrance. It is thought this might help mask the scent of the nest, fooling predators, or perhaps it works to attract insects, the main diet of the owls.

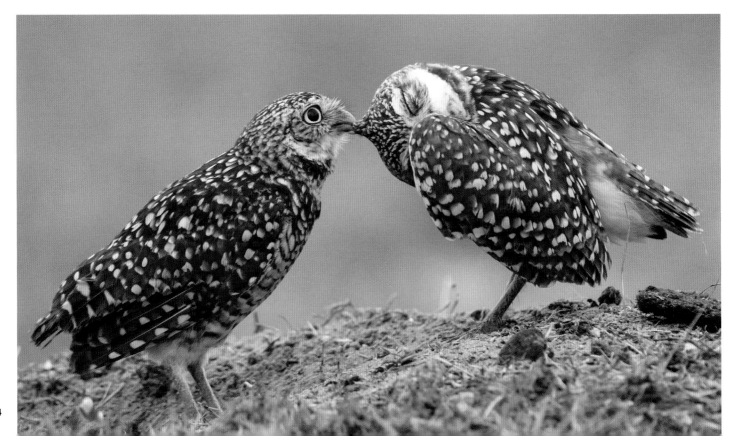

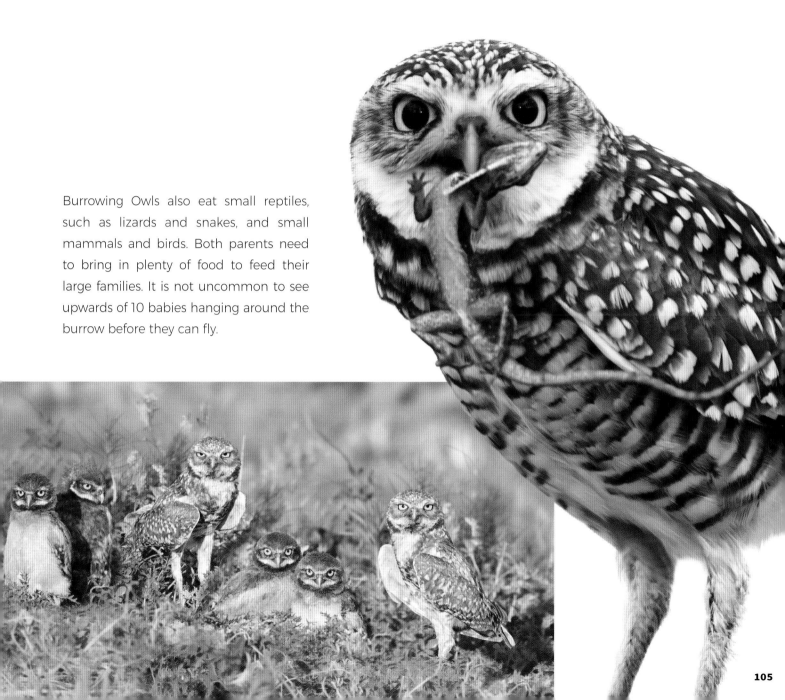

Burrowing Owls also eat small reptiles, such as lizards and snakes, and small mammals and birds. Both parents need to bring in plenty of food to feed their large families. It is not uncommon to see upwards of 10 babies hanging around the burrow before they can fly.

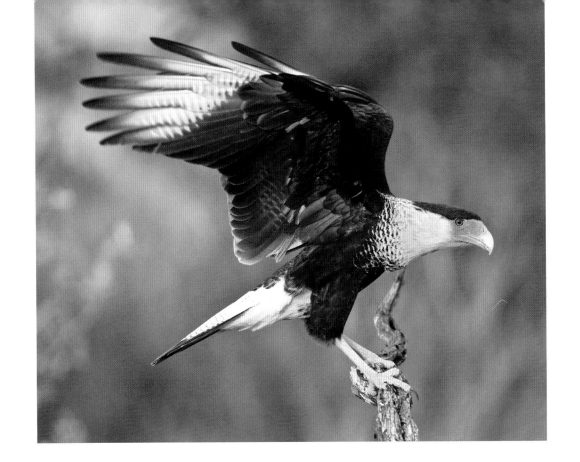

SCAVENGER FALCON, HUNTING ON FOOT

▶ **crested caracara**

The Crested Caracara is a very uniquely shaped and proportioned bird of prey. Although it is a member of the falcon family, which is a group of fast-flying aerial hunters, this raptor flies slowly and often scavenges for carrion and other food on the ground. It ranges throughout northern and central South America but reaches up into North America in Texas, Arizona and Florida, where small populations reside year-round.

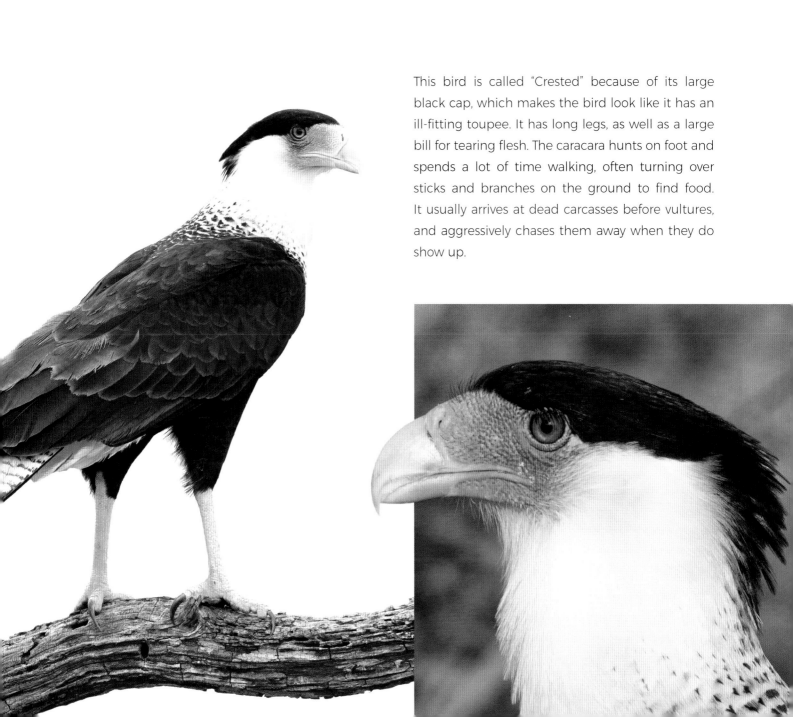

This bird is called "Crested" because of its large black cap, which makes the bird look like it has an ill-fitting toupee. It has long legs, as well as a large bill for tearing flesh. The caracara hunts on foot and spends a lot of time walking, often turning over sticks and branches on the ground to find food. It usually arrives at dead carcasses before vultures, and aggressively chases them away when they do show up.

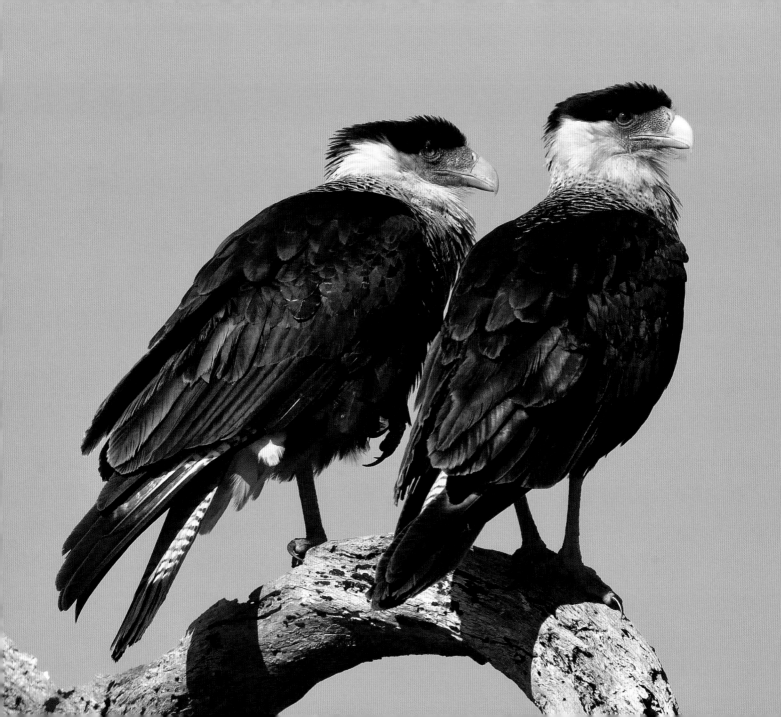

Caracaras are usually found alone or in pairs. I have often seen one or two of these birds flying straight down the centerline of a road at daybreak, searching for unfortunate critters that were hit by vehicles overnight. When caracaras spot roadkill, they circle it and land at a distance, making sure it's safe to approach. They often fly off with smaller prey and feed on larger animals on-site.

Similar to the Burrowing Owl, the caracara inhabits open country and does fairly well around people, often nesting on large cattle ranches. The population in Florida is a disjunct population that was once part of the population that stretched from Florida to Texas. It is believed that the Florida population dates back to over 12,000 years ago. As habitats changed, this population was cut off from the main group and has persisted, living in a small area of the west central part of the state.

Mated pairs will make a large stick nest in a palm tree, a mesquite species, or even in a large cactus. They nest in winter from December to April, so the young are out of the nest before the hot summer.

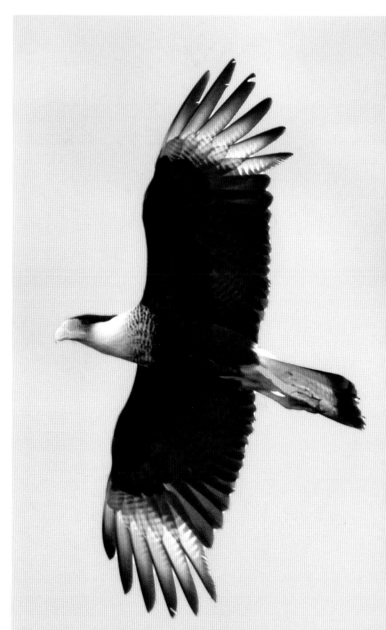

apple snails

APPLE SNAIL AFICIONADO

▷ **snail kite**

Specialization and adaptation are important ways that birds survive through the ages. The Snail Kite is an example of a highly specialized bird. As the name indicates, Snail Kites eat snails, and in particular, apple snails, which are large, native, freshwater mollusks with an oval shell.

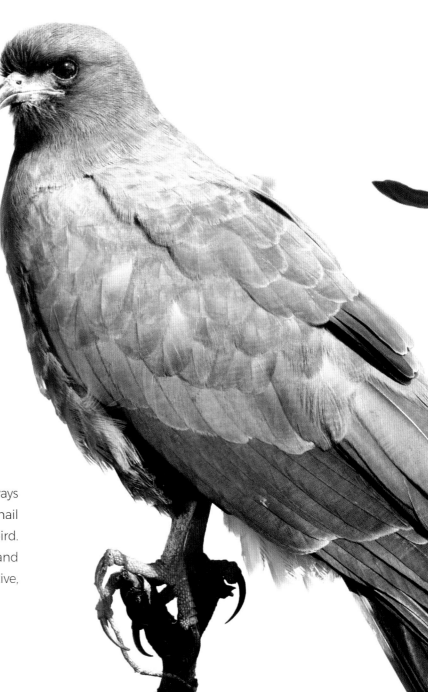

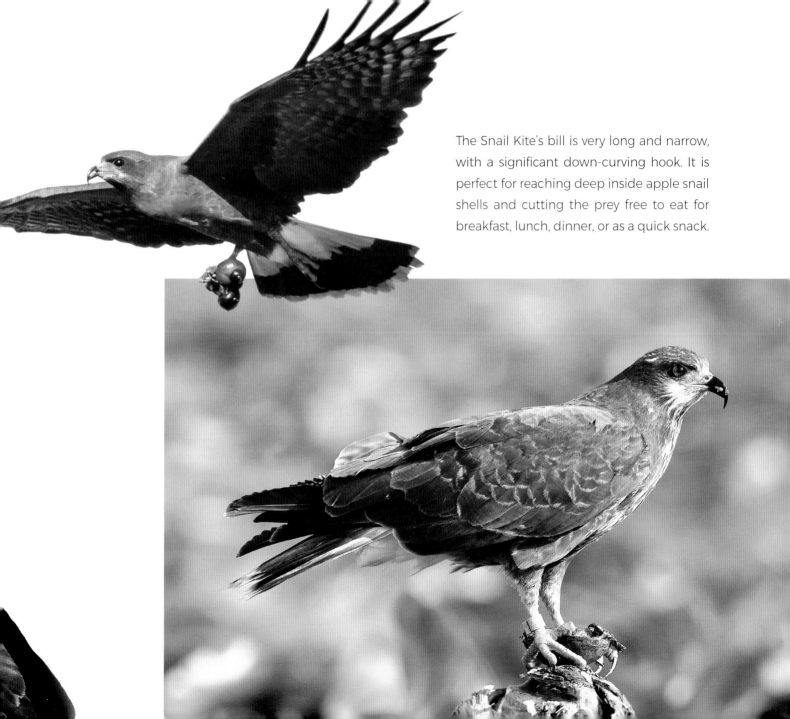

The Snail Kite's bill is very long and narrow, with a significant down-curving hook. It is perfect for reaching deep inside apple snail shells and cutting the prey free to eat for breakfast, lunch, dinner, or as a quick snack.

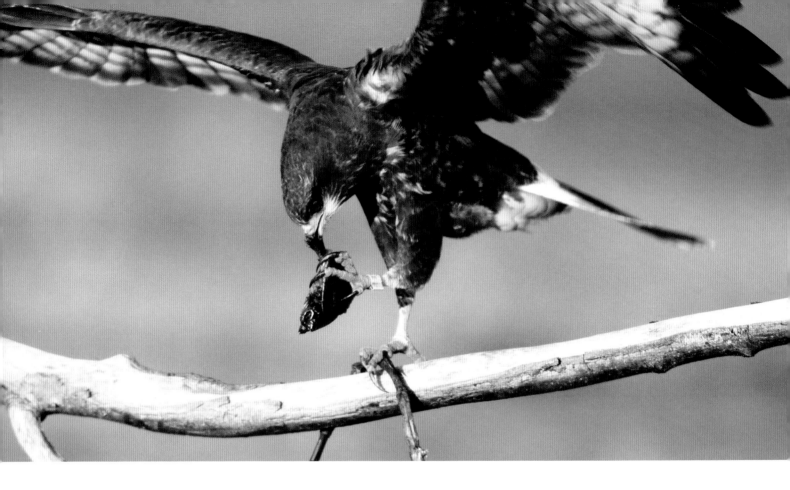

In Florida, the Snail Kite has a population of fewer than 400 breeding pairs and is considered an endangered species. The drainage of freshwater lakes around the state and the control of water levels in the Everglades combined with the decline of apple snail populations have reduced the kite's population to this historic low number.

The problem with being a highly specialized species is that if the food supply diminishes, so does the population. In response to decreased apple snail populations, the kites have been adapting to eat other foods; specifically, crayfish and turtles. However, it is believed that they will consume these alternative foods only temporarily, when the apple snails are scarce.

Unlike most raptors, male and female Snail Kites are dimorphic—they don't look the same. The male is dark bluish gray with a bright white rump and black tail. The female is light brown with a heavily streaked underside and is slightly larger than the male. Both share the large, curved, black and orange bill and long orange legs.

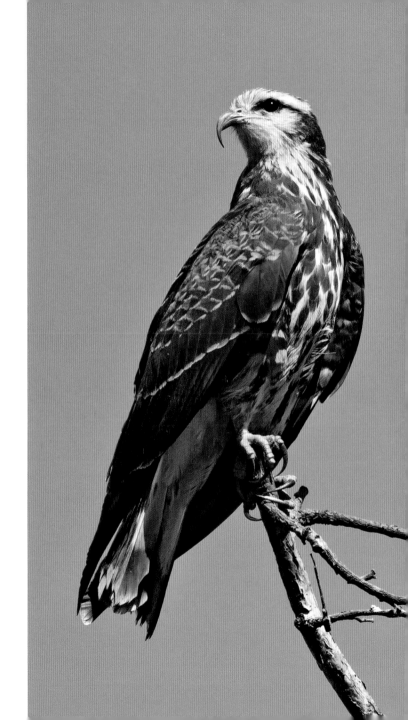

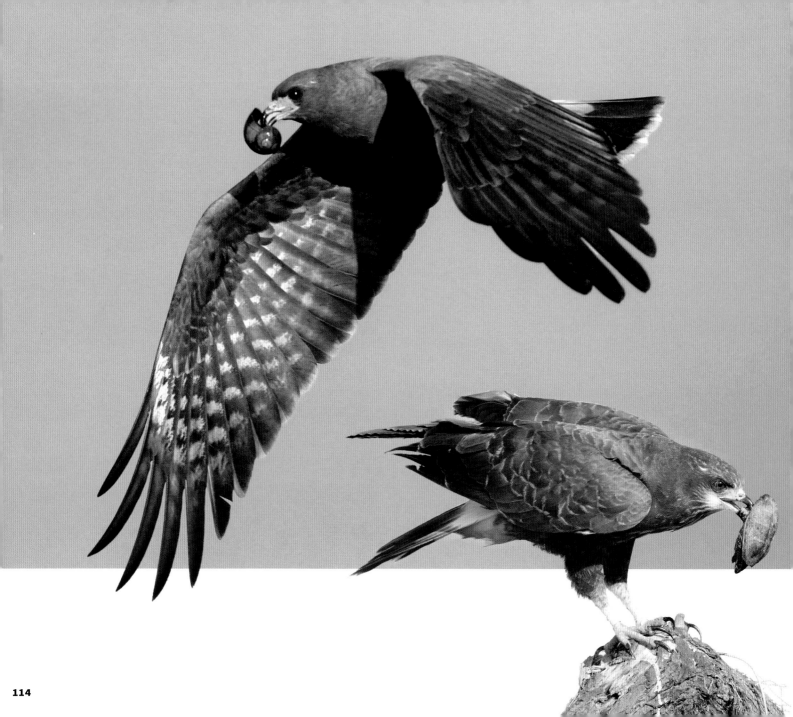

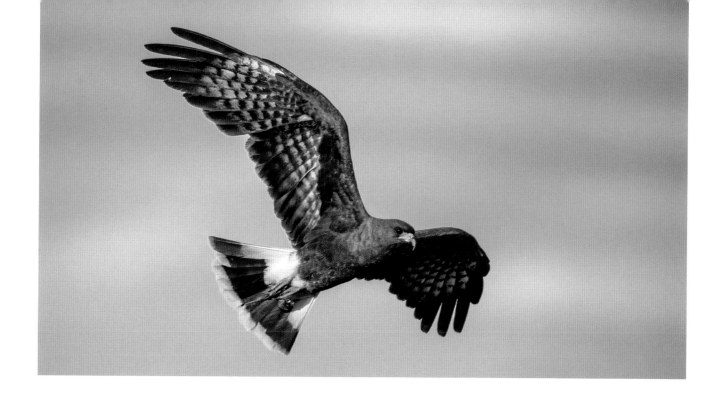

Snail Kites fly low over the water to hunt for snails near the surface. When they spot one, they quickly make a U-turn in the sky and drop down on the prey. Usually they fly to a favorite feeding perch, where they extract the snail from its shell. Once the snail is cut free, they drop the empty shell, adding to the pile accumulating below.

In winter, small groups of kites gather in freshwater lakes and rivers. During the breeding season, several pairs will form small colonies. The males perform courtship flights with deep, exaggerated wing beats and short dives near perched females, often bringing them gifts of snails. Their nests, which are in a shrub or small tree that normally hangs over the water, are usually no higher than 10 feet above the surface.

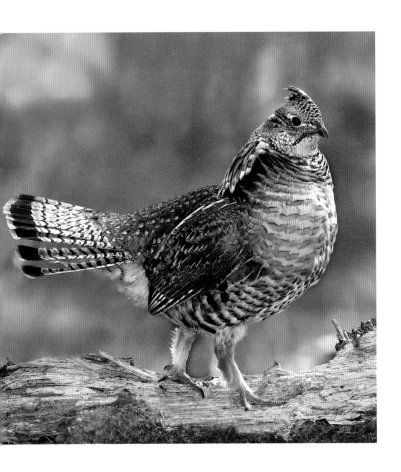

PERCUSSION PERFORMANCE ON LOGS

▶ **ruffed grouse**

The silent stalker of the woods, the Ruffed Grouse distinguishes itself from all other grouse in North America during the mating season. Its courtship display is like none other, consisting of an entirely nonvocal acoustic performance.

A courting male begins by choosing a fallen log deep in the woods. He often uses this same log for many years and stands on the same spot, leading to a worn area over time and a pile of scat that can be 6–8 inches tall. Here, he rapidly beats his wings, creating a low-frequency sound that is often felt before it is heard. Studies show that the drumming wings of a displaying Ruffed Grouse can be heard a quarter mile away, or more!

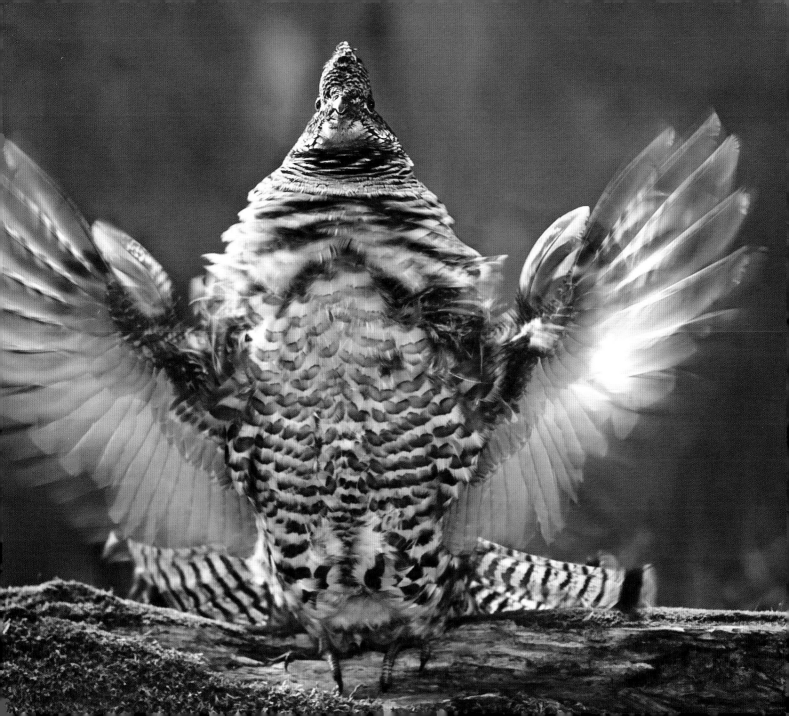

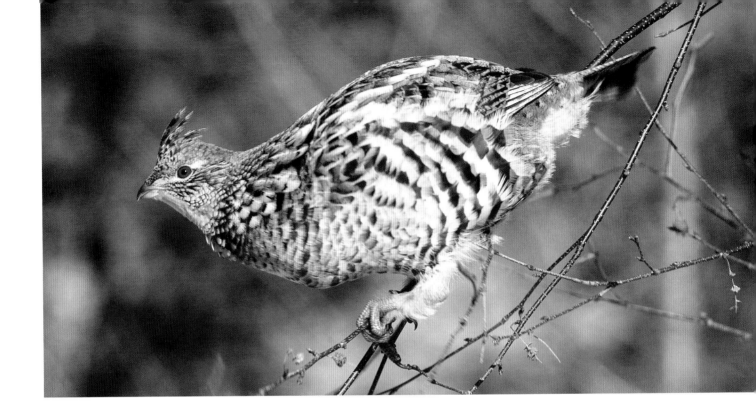

Ruffed Grouse spend most of their time on the ground but will fly up into tree branches to eat leaf and flower buds during winter and spring. In winter, where snow is deep and temperatures get very cold after sunset, Ruffed Grouse will dive into a snowbank to spend the night. They also do this during winter storms that last for several days. Serving as a blanket, the snow keeps the grouse warm and hidden from predators as well.

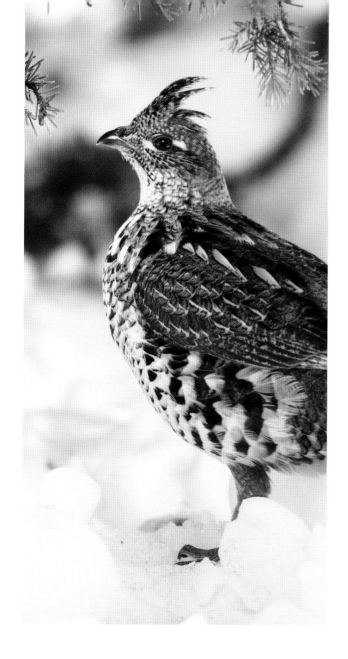

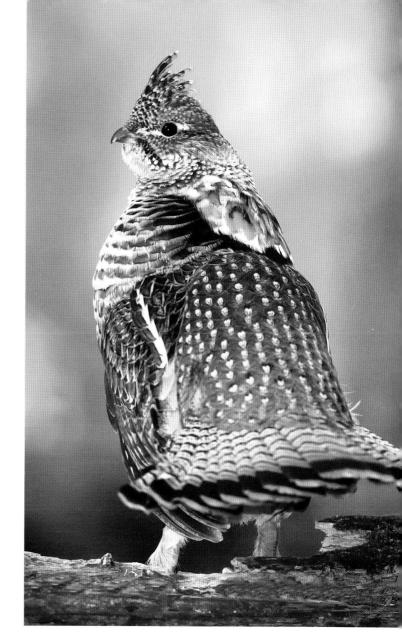

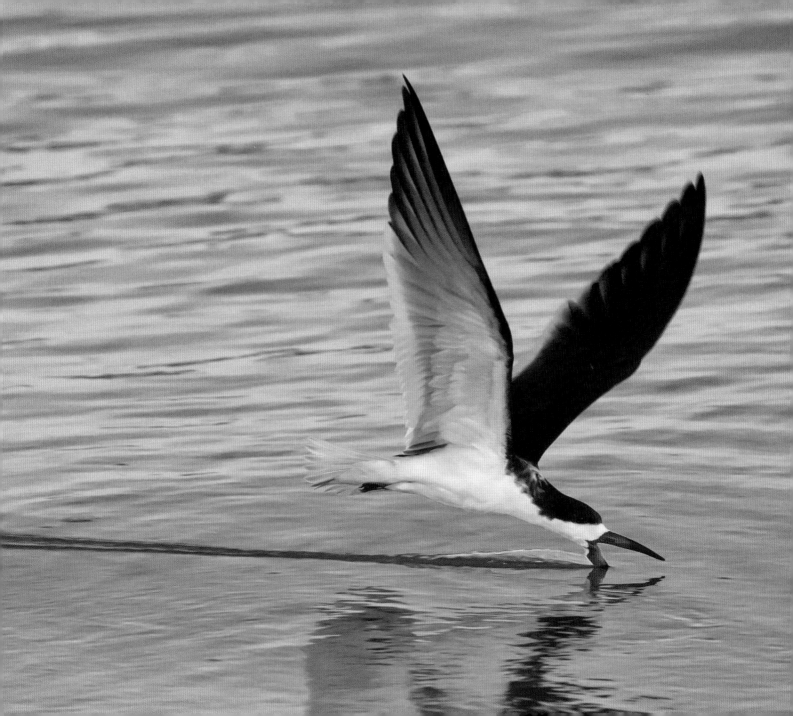

SKIMMING ALONG THE COAST

▶ black skimmer

A bird's bill can tell you a lot about the food it eats. Birds with large, thick bills, such as grosbeaks, crack open thick hulls and hard outer shells to eat the seeds enclosed. Birds with long, pointed bills, such as hummingbirds, sip nectar from deep within flowers. Black Skimmers are coastal birds with a distinctive bill design. Their lower bill is very thin and significantly longer than their upper bill, making it perfect for skimming the surface of water for food.

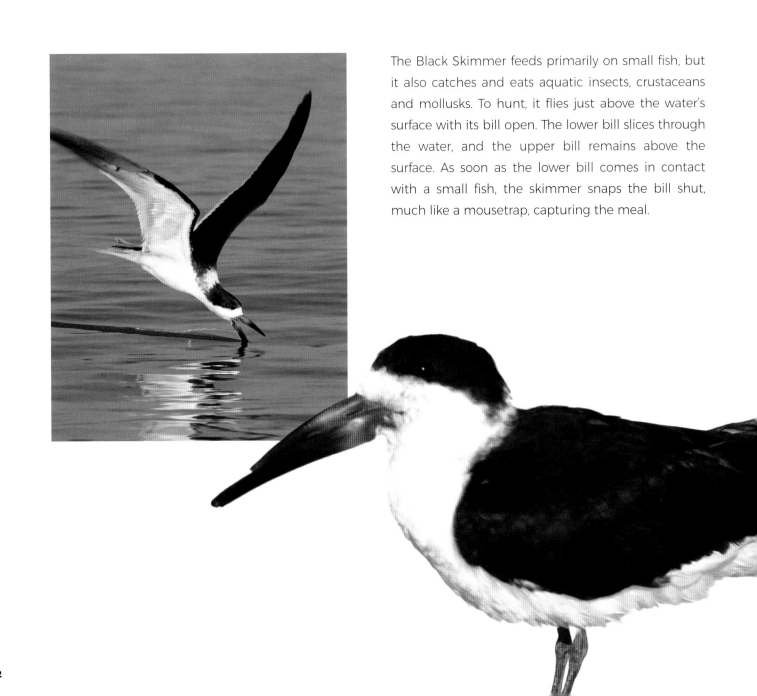

The Black Skimmer feeds primarily on small fish, but it also catches and eats aquatic insects, crustaceans and mollusks. To hunt, it flies just above the water's surface with its bill open. The lower bill slices through the water, and the upper bill remains above the surface. As soon as the lower bill comes in contact with a small fish, the skimmer snaps the bill shut, much like a mousetrap, capturing the meal.

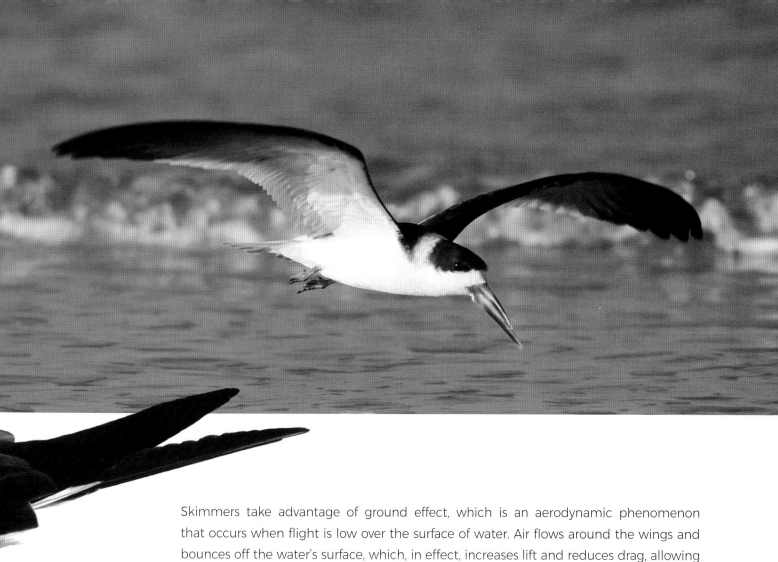

Skimmers take advantage of ground effect, which is an aerodynamic phenomenon that occurs when flight is low over the surface of water. Air flows around the wings and bounces off the water's surface, which, in effect, increases lift and reduces drag, allowing for effortless flight. This is why the flight of skimmers just above the water looks so easy. However, ground effect also traps skimmers in flight near the surface and prevents them from rising higher. To break free, they need to give a few power strokes to gain altitude.

Black Skimmers are almost always in small flocks. They move together up and down beaches and backwaters in search of shallow water, where fish get trapped after the tide goes out. Once they find a suitable feeding site, the birds zip back and forth, hunting low over the water.

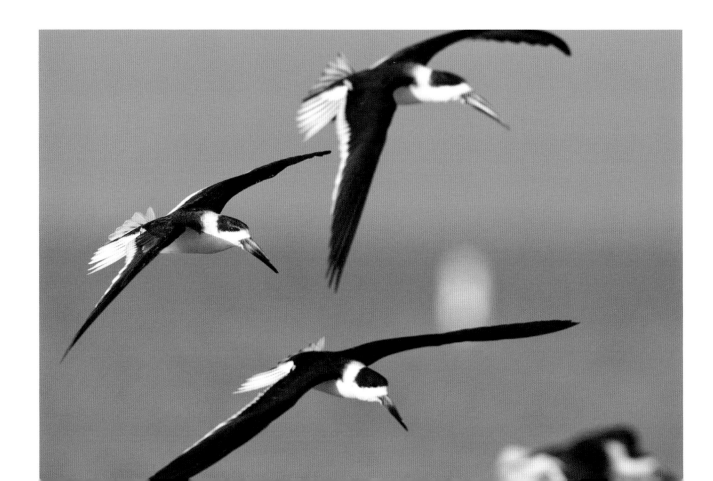

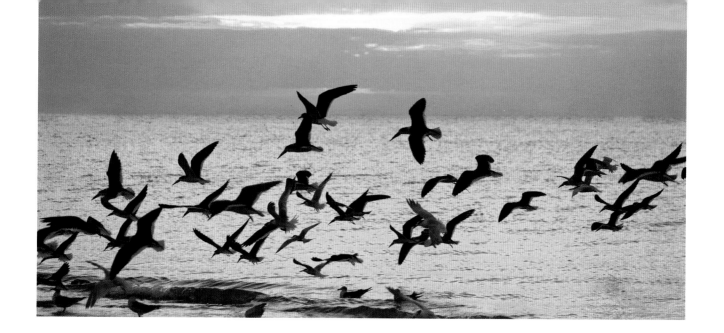

When skimmers aren't hunting and feeding, they rest on beaches and sandbars while facing into the wind, which helps them to take flight at a moment's notice. They have a slow and graceful flight on long, arching wings.

Skimmers nest on sandy beaches along the U.S. coast from the Carolinas to Texas. Usually they nest alongside terns and plover, and even gulls. They dig a shallow depression in the sand and lay 3–7 heavily marked eggs. For about 22 days, the parents take turns incubating the eggs, but the male does more of the incubating and brooding than the female.

Before the young can fly, hatchlings will bury themselves in sand at the approach of predators, effectively hiding in plain sight. Skimmers are the only birds in North America that have vertical pupils, much like a cat. However, because their eyes are dark, this atypical feature often goes unnoticed.

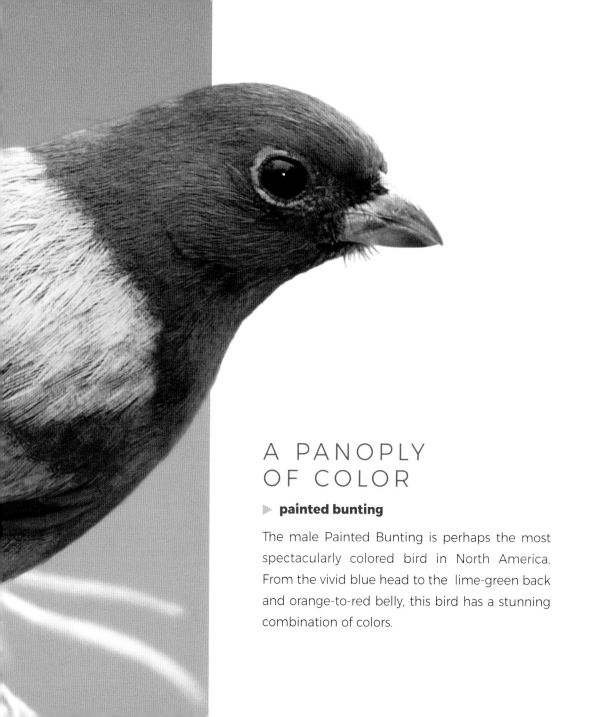

A PANOPLY OF COLOR

▶ **painted bunting**

The male Painted Bunting is perhaps the most spectacularly colored bird in North America. From the vivid blue head to the lime-green back and orange-to-red belly, this bird has a stunning combination of colors.

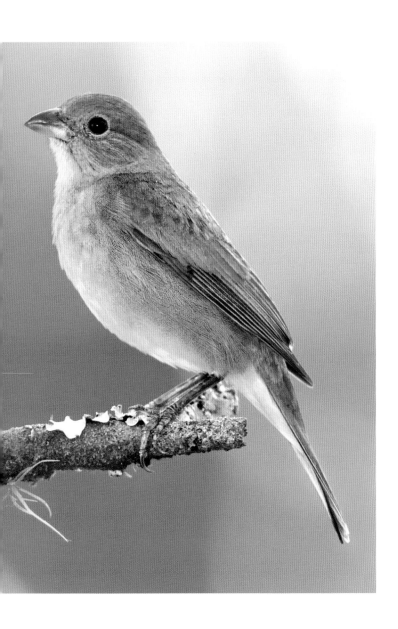

Buntings are in the same family as cardinals and grosbeaks and are closely related. Nearly all of the birds in this family are brightly colored and marvelous to see.

The bright plumage of male buntings develops in the second year of life. During the first year, they look nearly identical to the females, which are rather unimpressive. Females are plain green, unlike the multicolored male adults.

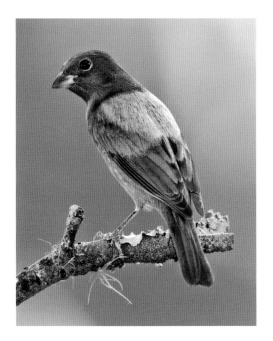

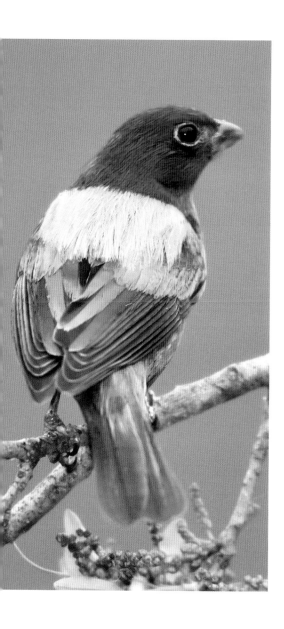

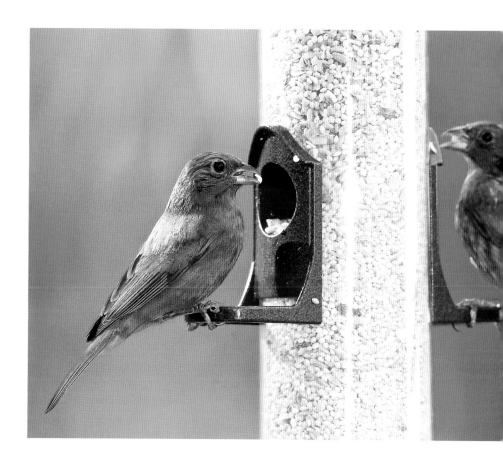

Painted Buntings are backyard birds that visit feeders in Texas, Louisiana, Oklahoma and other states in the South. Some individuals winter in southern Florida, but the vast majority migrate to the tropics of Central and South America, the Bahamas, Cuba and Jamaica.

Even though adult male buntings are so outrageously colored, they can often be difficult to spot. Shy and secretive, they live in thick hedges, scrublands and woodlands choked with vegetation. They move around on the ground under the tangle of branches or through leafy growth without being seen. This may be a survival strategy to conceal themselves from predator hawks, such as Cooper's Hawks.

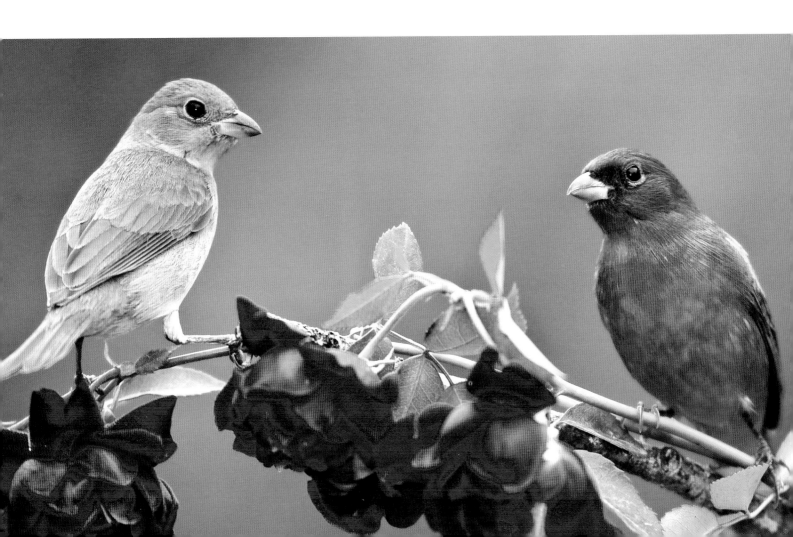

You can draw buntings into your backyard with seed feeders. Like cardinals and grosbeaks, buntings also have large, thick bills that are perfect for cracking open seed shells and crushing insects.

During the breeding season, males grow much less shy and become territorial, engaging in bloody fights with neighboring males. To attract a female, a male will take an exposed perch and sing loudly. When a female comes near, he also gives a visual display, flying like a butterfly with exaggerated wing beats. Afterward, he quivers his wings and bows his head, showing off his bright green back directly in front of the female.

The female judges the male's potential as a mate by his plumage. The brightness and vibrancy of his feathers indicate the fitness of his health and the abundance of food in his territory. If he doesn't have impressive feathers, she will not accept him and will continue to look for another mate.

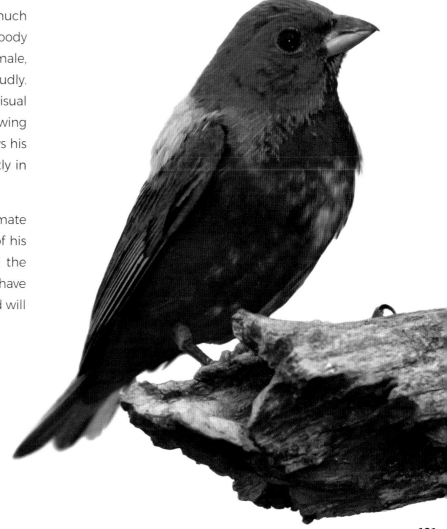

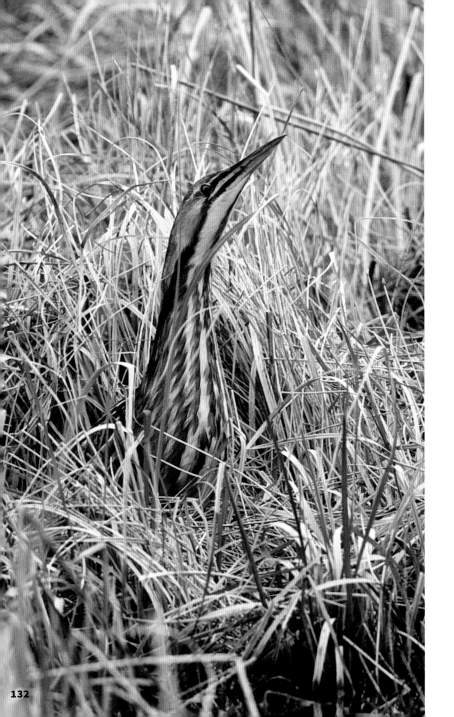

CAMOUFLAGING AT ITS FINEST

▷ **american bittern**

The American Bittern is a fairly large bird that takes camouflage plumage to a new level. Tall and thin with long legs and a long, pointed bill, the bittern is feathered in a concealing combination of gray and brown with vertical streaking.

Bitterns stalk around wetlands so slowly that you could almost say they move at glacial speed. Much of the time they just stand still, holding their bills skyward as they watch for the movement of fish, frogs, snakes and large insects. With eyes in an advantageous position on their heads, they can see below their bodies as they hold their heads upright and motionless.

The streaked, earthy coloring of the plumage helps these birds blend into the grasses and reeds of their environment. When they really want to be hidden, they sway back and forth in the wind, matching the motion of the vegetation waving in the breeze.

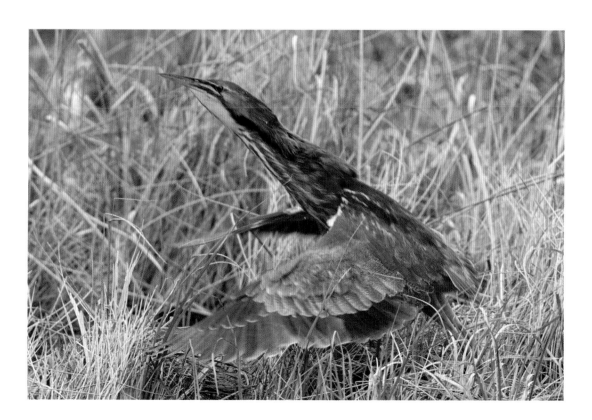

Your best opportunities to see bitterns are when they return to the wetlands in early spring, before the cattails and bulrush turn green and grow tall. When you first spot them, they will usually freeze in place to blend into the surroundings. If you approach, they will flush and fly off, giving a hoarse croaking sound.

Bitterns are typically heard more than seen. In spring, the males call from the wetlands to contact the females. They make a gulping sound from deep in the throat and repeat this over and over. Similar to the sound of a mechanical pump, this call gave rise to the nickname, Slough Pumper.

Nesting is another secretive affair. The female chooses a nest site surrounded by thick aquatic vegetation and gathers plants to build a mound nest as high as 8–10 inches above the water's surface. She incubates and raises the young alone.

At one time, American Bitterns were fairly common in North America. Now, due to habitat loss and the use of insecticides, the population is steadily dropping. According to the North American Breeding Birds Survey, bitterns have declined a whopping 43 percent in just 49 years, from 1966 to 2015.

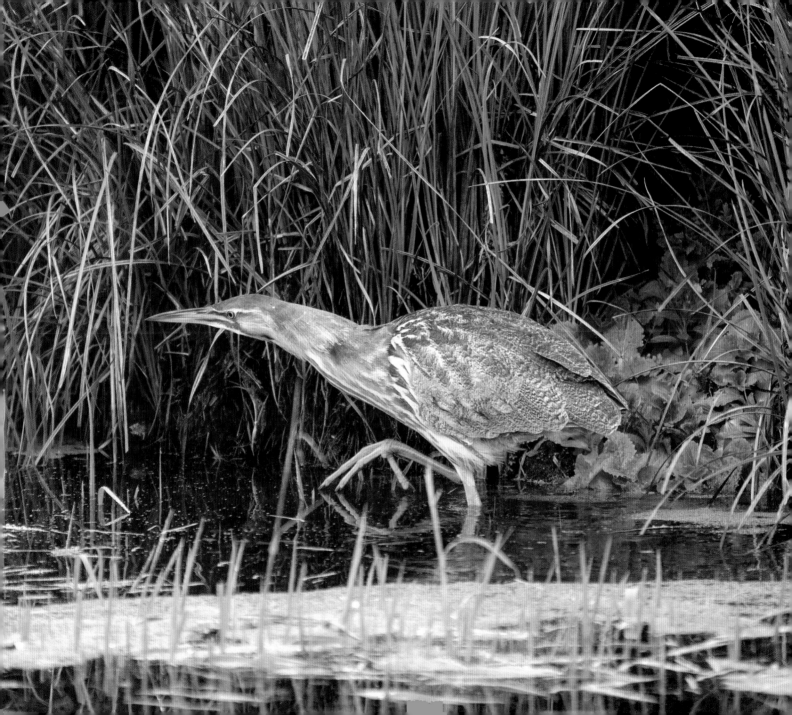

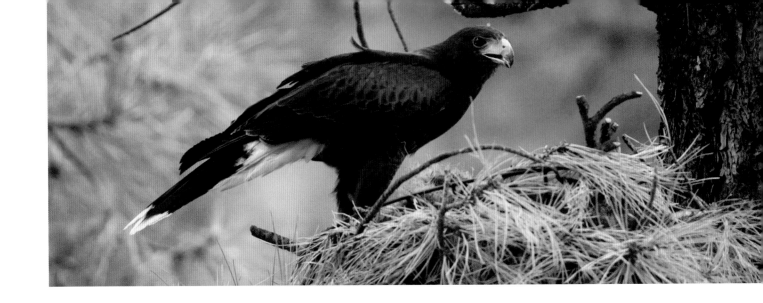

SMART, SOCIABLE AND POPULAR

▶ **harris's hawk**

Harris's Hawks are sleek, handsome raptors with bold brown, black, white and rusty red markings. They have a very limited range in North America, so we are fortunate to have a small population along the borders of a few arid southern states, namely Texas, Arizona and New Mexico. They live in open woodlands and scrub deserts, but they need a small stand of tall trees for nesting. When this is absent, they nest in the tall arms of a saguaro cactus or deep within a thick stand of shrubs.

This hawk is the most social raptor in North America. They cooperate with one another, attending and caring for each other's nests and young, and they are well known for hunting in family units as a team, similar to a wolf pack. They search for prey using their eyesight, which is thought to be 8–10 times better than that of humans. After locating larger prey, such as a jackrabbit or cottontail, they take turns chasing to wear it down. When the prey hides in shrubbery, the family takes up strategic posts to surround it. One will flush it out, and the others follow and catch it. They all share in the bounty.

This cooperative behavior is more effective for capturing larger prey than if individuals were hunting on their own. Independently, they hunt for lizards, snakes and small mammals, such as mice. These smaller meals are usually not shared.

Harris's Hawks are resourceful in other ways as well. In a unique hunting behavior known as back stacking, they perch on the backs of one another when there is no other place to land, stacking up on each other like a totem pole.

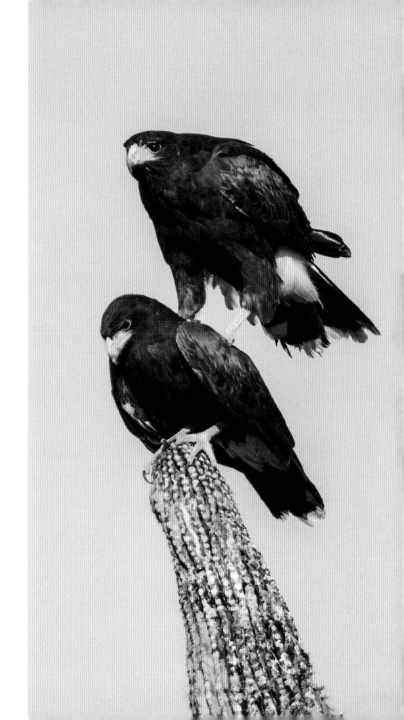

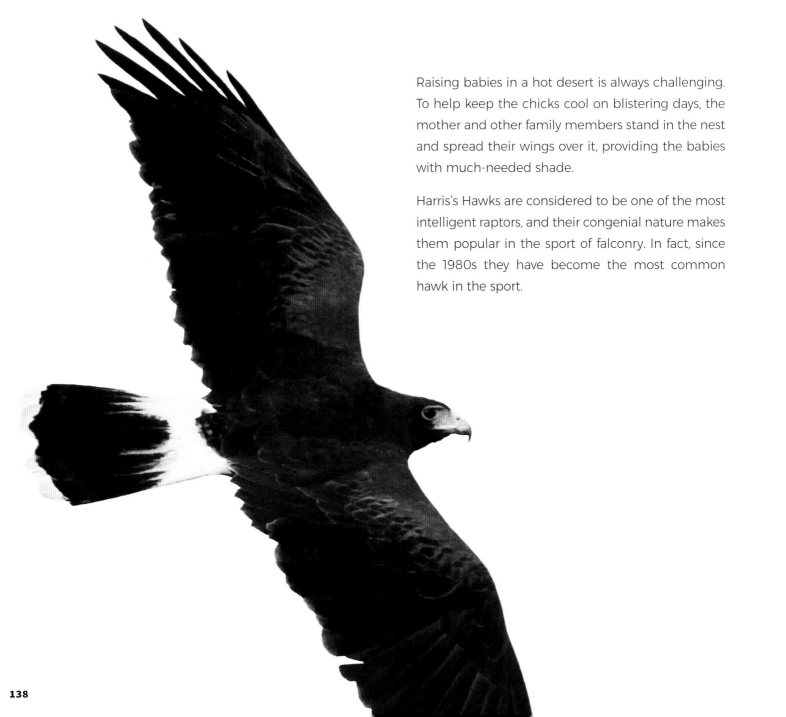

Raising babies in a hot desert is always challenging. To help keep the chicks cool on blistering days, the mother and other family members stand in the nest and spread their wings over it, providing the babies with much-needed shade.

Harris's Hawks are considered to be one of the most intelligent raptors, and their congenial nature makes them popular in the sport of falconry. In fact, since the 1980s they have become the most common hawk in the sport.

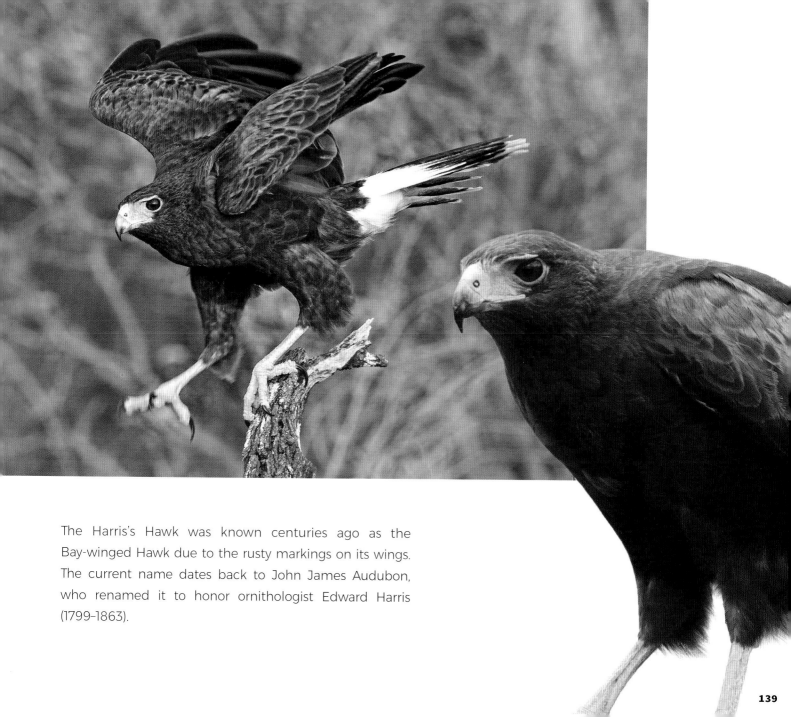

The Harris's Hawk was known centuries ago as the Bay-winged Hawk due to the rusty markings on its wings. The current name dates back to John James Audubon, who renamed it to honor ornithologist Edward Harris (1799–1863).

THE EMBODIMENT OF DIVERSITY

North America is a magnificent place for birds. Originally, it was part of Pangaea, a supercontinent that broke apart about 175 million years ago into the continents we know today. The separate landmass of North America allowed birds to evolve under their own unique conditions and habitats, producing the rich and wonderful variety of species that we see and love today.

Northern Shrike

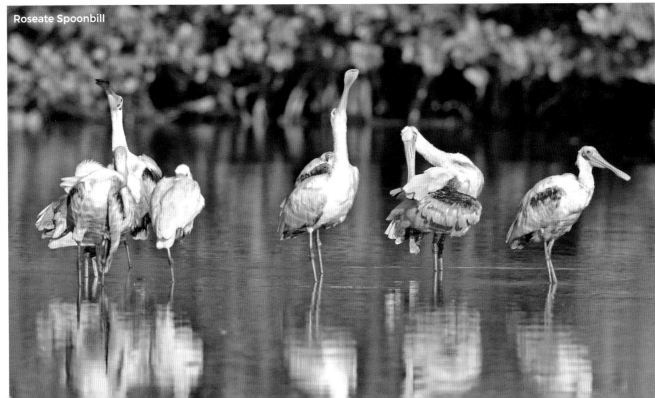

Roseate Spoonbill

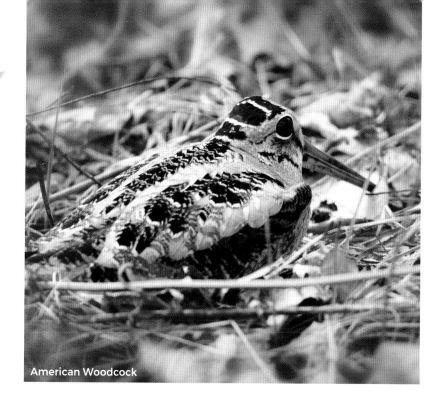
American Woodcock

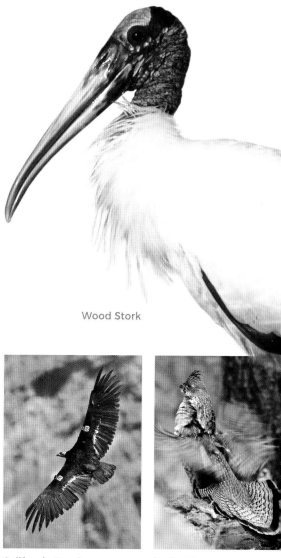
Wood Stork

From hummingbirds and buntings to grouse, puffins and eagles, our North American birds are the embodiment of diversity. They adorn our backyards with bright colors, amaze us with their behaviors, and thrill us as they soar in our national parks.

I hope that you enjoyed learning about some of our most interesting North American birds presented in this book. Some came close to extinction, but thanks to environmental education and many other efforts, they returned from the edge of annihilation to survive, and even thrive, to this day.

California Condor

Ruffed Grouse

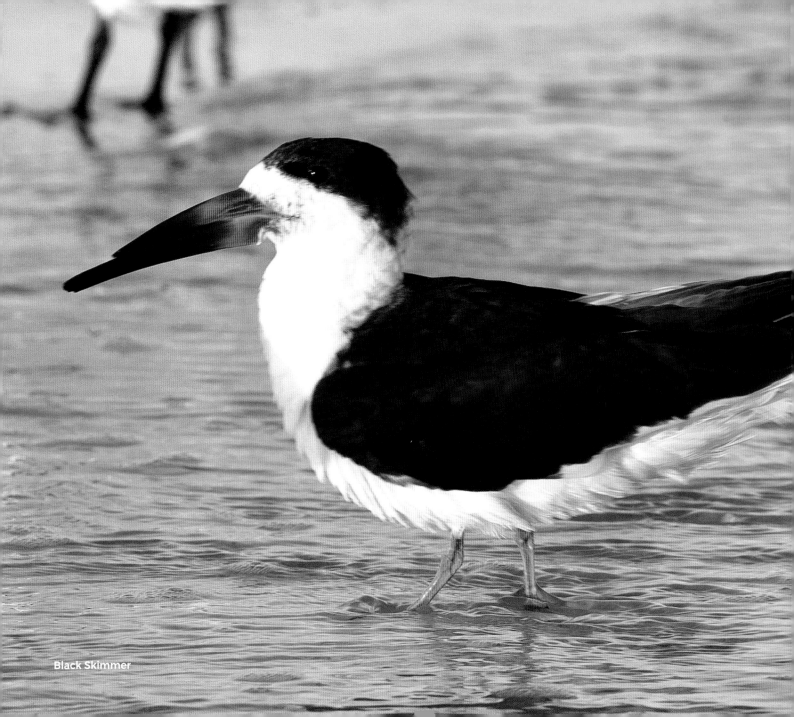

Black Skimmer

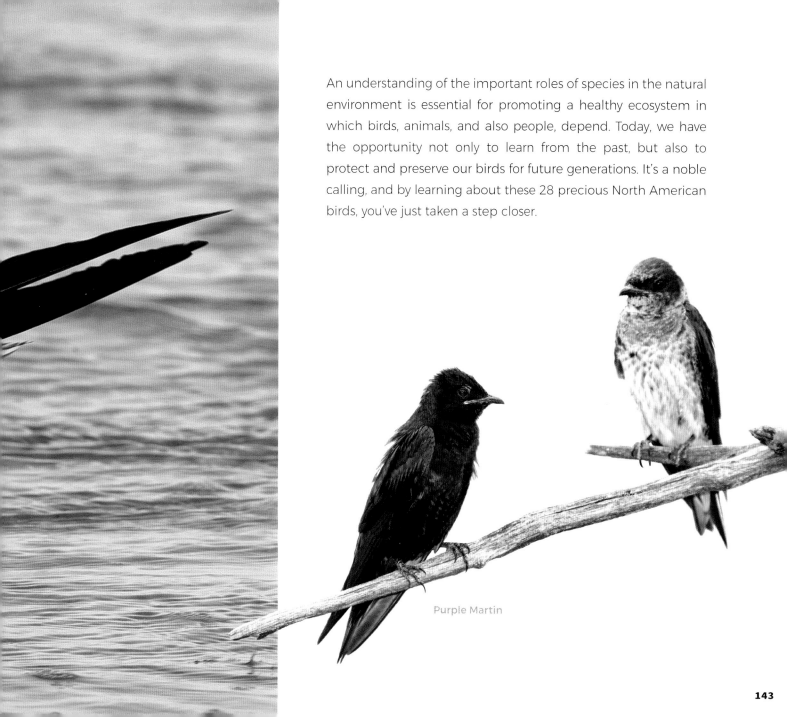

An understanding of the important roles of species in the natural environment is essential for promoting a healthy ecosystem in which birds, animals, and also people, depend. Today, we have the opportunity not only to learn from the past, but also to protect and preserve our birds for future generations. It's a noble calling, and by learning about these 28 precious North American birds, you've just taken a step closer.

Purple Martin

ABOUT THE AUTHOR

Naturalist, wildlife photographer and writer Stan Tekiela is the author of the popular Wildlife Appreciation book series that includes *Backyard Birds* and *Cranes, Herons & Egrets*. He has authored more than 175 field guides, nature books, children's books, wildlife audio CDs, puzzles and playing cards, presenting many species of birds, mammals, reptiles, amphibians, trees, wildflowers and cacti in the United States.

With a Bachelor of Science degree in Natural History from the University of Minnesota and as an active professional naturalist for more than 30 years, Stan studies and photographs wildlife throughout the United States and Canada. He has received various national and regional awards for his books and photographs. Also a well-known columnist and radio personality, his syndicated column appears in more than 25 newspapers and his wildlife programs are broadcast on a number of Midwest radio stations. Stan can be followed on Facebook and Twitter. He can be contacted via www.naturesmart.com.